Photography: Sean Kirby
Editor: Jill K. Richardson
Book Design and Production:
Meral Dabcovich, Visual Perspectives
in collaboration with S.B.

ISBN: 0-9635318-2-4

Published by Pucker Gallery, Boston, in association with Brandeis University Press
Distributed by University Press of New England, Hanover, NH 03755

© 1997 Pucker Gallery

Pucker Gallery
171 Newbury Street
Boston, Massachusetts 02116
(617) 267-9473; Fax: (617) 424-9759

Printed in Hong Kong by South China Printing Company (1988) Limited

Library of Congress Cataloging in Publication Data

Bak, Samuel.
　　Landscapes of Jewish Experience: paintings/by Samuel Bak;
essay and commentary by Lawrence L. Langer.
　　　　p.　cm. -- (The Tauber Institute for the Study of European Jewry series ; 25)
　　"In association with Brandeis University Press, distributed by the
University Press of New England, Hanover and London."
　　Includes bibliographical references.
　　ISBN 0-9635318-2-4
　　1. Bak, Samuel -- Themes, motives.　2. Holocaust, Jewish
(1939-1945), in art.　I. Langer, Lawrence L.　II. Title.
III. Series.
ND979.B27A4 1997
759.9564--dc21
　　　　　　　　　　　　　　　　　　　　　　　　　　　　97-19468
　　　　　　　　　　　　　　　　　　　　　　　　　　　　CIP

LANDSCAPES OF JEWISH EXPERIENCE

LANDSCAPES OF JEWISH EXPERIENCE

paintings by
SAMUEL BAK

essay and commentary by
LAWRENCE L. LANGER

Published by Pucker Gallery, Boston
in association with Brandeis University Press
Distributed by University Press of New England, Hanover and London

The Tauber Institute for the Study of
European Jewry Series

Jehuda Reinharz, General Editor
Michael Brenner, Associate Editor

The Tauber Institute for the Study of European Jewry, established as a gift to
Brandeis University from Dr. Laszlo N. Tauber, is dedicated to the memory of the
victims of Nazi persecutions between 1933 and 1945. The Institute seeks to study
the history and culture of European Jewry in the modern period. The Institute has
a special interest in studying the causes, nature, and consequences of the European
Jewish catastrophe within the contexts of modern European diplomatic, intellectu-
al, political, and social history.

This book is number 25 in the series.

Essay

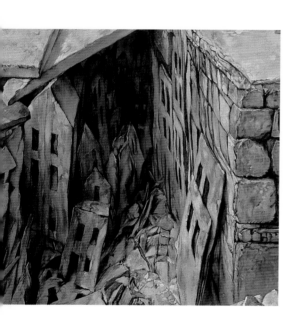

Page 45

Painting, like literature, is a reciprocal art. A book without a reader is inert, stagnant, a candidate for extinction. Similarly, a painting without a viewer is a lifeless object, drained of kinetic force. Viewer and reader invest canvas and page with a vitality that draws its energy from the eye and the mind of an attentive human responder. We cannot look at the monumental paintings in Samuel Bak's *Landscapes of Jewish Experience* series without feeling the tension that slowly mounts as we grope to interpret their images. The shapes and spaces on the canvases first unite with each other, creating a fragile balance between substance and ruin. Then they leap forth to challenge us with the dual appeal of chaos and form, as we strive to populate the rubble with a living presence so visibly absent from most of the scenes before us.

Although all art requires active involvement, Holocaust art is especially demanding. Memory is a crucial catalyst in this process. The lack of human figures in most of Bak's forsaken landscapes will be a mystery only to those who ignore the incandescent shimmer that so often ripples through their atmosphere, or the sinister smokestacks that rise like accusing fingers from a barren terrain. An unholy glow is all that lingers from millions of bodies consumed by fire. Among other possibilities, these paintings are dramatic bulwarks against amnesia. They are reminders of a sacred past, criminally besieged, crowded with emblems of a ravaged civilization. They contain fragments of a giant jigsaw puzzle called Creation that burden viewers with the task of retrieving its missing pieces, while leaving them wondering whether those pieces may not have been lost forever.

To minimize the grimness of Bak's art is to falsify its content. "My paintings," Bak admitted more than a decade ago, convey "a sense of a world that was shattered, of a world that was broken, of a world that exists again through an enormous effort to put everything together, when it is absolutely impossible to put

2

it together because the broken things can never become whole again. But we still can make something that looks *as if* it was whole and live with it. And more or less this is the subject of my painting, whether I paint still lives, or people, or landscapes, there is always something of that moment of destruction there. Even if I do it with very happy and gay colors, it has always gone through some catastrophe."

What is "that moment of destruction"? Bak grew up in Vilna, the Jerusalem of Lithuania, a center of Yiddish learning that rivaled any in Europe. With the outbreak of war in 1939, the city was transferred from Poland to Lithuania. The Soviet Union occupied Vilna in June 1940, when Bak was a child of seven, and the Germans invaded a year later; from that point, the dismantling of Jewish culture and the destruction of Jewish life in Vilna began. When Russian troops re-entered the city in July 1944, only a few thousand of the 57,000 Vilna Jews who had been subject to Nazi rule were still alive. Among them were Bak and his mother. His father had been shot a few days before the liberators arrived. The two ghettos, sole remnants of a once thriving Jewish community, lay in shambles.

This is the kind of personal legacy that stalks the *Landscapes of Jewish Experience*. Bak's paintings comprise a visual testimony to the disaster, a profusion of images that admit us to an event many consider unimaginable. His canvases present relics of ruin and vestiges of order, a wasteland of Jewish tradition struggling out of its disarray, leaving his viewers to determine from this turmoil how much of a chance for renewal remains. A major strength of his vision is its refusal to commit to hope or despair. It reflects an art oscillating between expectation and dismay.

Alert viewers will notice in several of these paintings a *vov* and *gimel*, initial letters of the Vilna Ghetto, usually formed by odd scraps of wood and unobtrusively inserted into the visible text. They are cues to a vanished era, traces of a loss that is an unavoidable base for any effort to rebuild a future. Bak is much

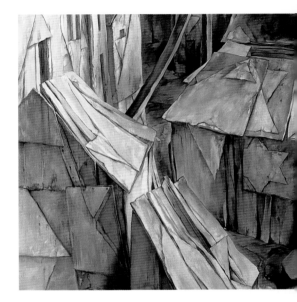

Page 41

too honest a painter to pretend that survivors could turn toward rebirth while slighting their splintered past. The vistas that draw the eye into a distance of mountain peaks or sea and sky in many of these paintings beckon with an uncertain promise. The masses in the foreground, the colossal boulders and huge blocks of granite, the graves and tombstones and crumbling Tablets of the Law, weigh heavily on the imagination, discouraging an easy flight into an unfettered tomorrow.

The fate of the Vilna Ghetto and its inhabitants is a model for the doom of all of European Jewry. The familiar emblems of Jewish continuity—the shabbat candles, the Star of David, the Ten Commandments—have not been vanquished, since they assert their presence even in the midst of a fretful gloom, but they declare themselves with a diminished vigor. Bak concedes the price the murderous Germans have wrested from the once sturdy symbols of Jewish existence, while declining to grant final victory to the assailants. If he can be said to celebrate anything in this series, it is the stamina of the spirit of Jewish memory, affected and even afflicted by the powers of darkness, but never entirely annulled.

Bak has faced the Holocaust, both in its private and its public features, through what might be called a poetry of redefinition. Poetry thrives on images, on the dynamic dialogue among them that stimulates a reader to a re-vision, and then a revision, of his or her prior sense of reality and of human experience. And this is precisely the lure of Bak's paintings. The so-called Final Solution has not extinguished shabbat candles, but forced them to light their sacred role in the shadow of the crematorium chimney. In *Trains*, smoke pours upward from the tips of the candle flames, inaugurating a profane sabbath and evoking a "yahrzeit" that many would prefer to dismiss. And since the Holocaust, who can ever again regard a train merely as a conveyance for traveling from one place to another? Those familiar with Claude Lanzmann's *Shoah* will know how the train, in

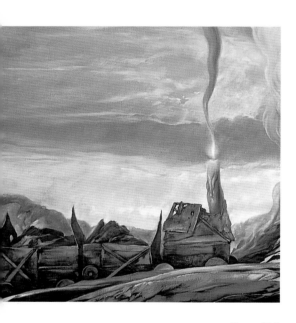

Page 113

one of its incarnations, has been enshrined forever as a vehicle of death. Meanwhile, we have no way of deciding whether the ominous cloud in the right background is encroaching or dispersing, threatening the journey or welcoming it toward a brightness beyond the smoldering pyre near the center of the painting.

A poetry of redefinition involves an altered sense not only of images, but of the lexicon that animates them, of the words and even the letters that grant us our means for noting the scenes around us. Bak gives us visual access to one of the basic principles of Holocaust art: it speaks to us with a language of tainted familiarity. The Ten Commandments have not lost their authority, but they address us now in a variety of tones, not excluding the ironic. "Thou shalt not murder" echoes with a hollow solemnity in a universe just awakening from the slaying of the people it was designed to enlighten. The role of the Divine Voice and its tokens of power and love is not revoked, but is summoned to a Job-like court of inquiry, as the ancient debate between the Lord and his people renews itself in a domain stained by the blood and ashes of European Jewry.

Page 73

In none of these paintings is this anxious dialogue more vivid than in From *Aleph to X* and *Othyoth* [Letters], both reflecting the decisive holy moment when God sealed his covenant with the Jews in flight from Egypt by giving them the Ten Commandments. In *From Aleph to X*, two giant tablets loom over the ruin of a crushed Jewish community. They are firmly planted in the earth, like outcrops from some earlier eruption. At their base lies a partly demolished Star of David whose vague yellow tint reminds us of its faded glory. Beside it rises the emblem of its nemesis, a chimney belching pallid smoke, drained of its virile pigment, flattened against the tablet as if etched into its facade. If faith is to endure, must the Torah be "rewritten" to include the legacy of Auschwitz? Has the abused Star of David any hope of being restored to its former spiritual grandeur in the galaxy of Jewish belief?

These are momentous issues, not easily resolved. The immense tablets command the site like mastodons of Hebrew law, but the history of the Holocaust has not left them intact. In *Othyoth* they have taken flight; unmoored from the landscape, they drift between sky and earth as if their future fortune must now be amended. What new revelation awaits us? The letters of the law, no longer embedded in stone, float free, though we are left to imagine what has shaken them loose and what their unfixed status entails. As if bathed in divine radiance, a golden aleph [א] crowns the picture, attesting the primacy of a revised text that has yet to be composed. Despite the vivid realism of the draftsmanship, the letters seem to have been cut from a celestial cover, a remnant of which may still cling to one of the crumbling tablets. Is this dismembered alphabet returning to its source, or seeking a new earthly prophet, a post-Holocaust Moses to guide surviving Jewry beyond their primal heritage to repair the damage wrought by their modern catastrophe?

Such challenges may sound fanciful, but Samuel Bak is not the only Holocaust artist to raise them in his creations. There is no evidence that he has been a disciple of the Nobel-prize winning poet Nelly Sachs, but anyone familiar with her verse will recognize an intimate kinship between the visions of the two. Her work helps us to appreciate the remarkable *literary* quality of Bak's achievement. The title of her first postwar volume, *In the Dwellings of Death*, and its initial poem, "O the Chimneys," signify the importance that a particular icon of disaster, so prominent in Bak's paintings too, plays in our imaginative response to the destruction of European Jewry. As post-Holocaust artists, they embrace a similar birthright, Sachs as a writer seeking to recover from the wounded word, and Bak as a painter from the wounded image. But in a more complex sense, although their technical bents may differ, for poet and artist alike words and images are inseparable; the task of moving an audience between sight and insight is at once visual and

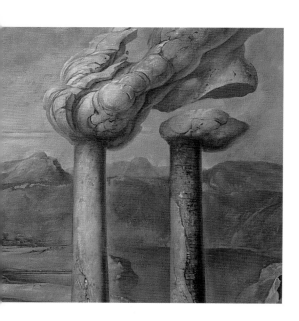

Page 53

6

mental. Words must be "seen," and images "read." Both artists share the conviction that the post-Holocaust bond between man and his spiritual future has turned enigmatic—one of Sachs's last series of poems is called "Glowing Enigmas"—launching for each of them a quest for new dimensions of perception. The context for this search is the impact that the slaughter of European Jewry has had on the sensibilities of the artist.

Anyone conversant with the deceitful speech and the fraudulent shapes devised to beguile Hitler's victims—"deportation" coded as "resettlement," gas chambers disguised as showers—will understand why the remolding of language and form are so important to the artistic imagination exploring ways to represent the calamity we call the Holocaust. The novel fusion of word with image is enshrined in the following plea from a poem by Nelly Sachs:

> *do not destroy the cosmos of words*
> *do not dissect with the blades of hate*
> *the sound, born in concert with the breath.*

Bak might have said the same about the cosmos of images, especially those associated with the early vitality of Jewish tradition. The need to protect familiar patterns from total annihilation drives Bak's creative energies, even as he charts a redesigned architecture of reality to contain them in a post-Holocaust universe.

The inspirations piloting Bak and Nelly Sachs at times seem identical, a resemblance all the more striking because during the war she was in exile in Sweden. "The dreadful experiences that brought me to the very edge of death and eclipse," she wrote, "have been my instructors. If I had not been able to write [for which we might read "paint"], I would not have survived. Death was my teacher. How could I have occupied myself with something else; my metaphors are my wounds. Only through that is my work to be understood." Bak's metaphors are his

Page 77

wounds too, throbbing and probably incurable, but paradoxically they proclaim a robust as well as an injured vision. His metaphors demand that we re-view, and then review, well-known models of spiritual consolation and consider how they may have been recast by secular ruin.

The painting *Shema Yisrael* heralds an unorthodox message amidst the havoc of a hallowed spot. Here the summit of a modern Sinai shines forth in surprising splendor, but only the name of the Lord is inscribed on the tablets at the peak. Strewn on the mountain's slopes, like shattered tombstones, are the wreckage of the earlier dispensation, the letters of their revelations scattered amongst the rubble like a jumbled text. The eye is drawn compulsively from a shadowed foreground to the blank tablets at the top, waiting to be engraved anew, presumably by a Divine Hand. Some sunlight seems to gleam through fleecy, drifting clouds. But the Chosen People are nowhere to be seen, their absence raising the unsettling question of how the effort to exterminate them has disrupted the ancient narrative of Genesis and Exodus.

Bak's metaphors may be read in many ways: this is a major source of their appeal. Semblances of the Ten Commandments wander through his paintings like leitmotifs from a Wagner opera. They lead an intertwined life, no single advent being independent of all the others. The viewing experience awakens musical as well as literary vibrations, each image enriching its fellows by a sequence of modulations, like the development of a symphonic theme, creating a synthesis of aesthetic response that draws on numerous arts. We do not trace the evolution of the artist's judgment as we move from painting to painting, but endure instead the conflict of an incessant and unresolvable inquiry, variously displayed. Nothing less than the destiny of the Jewish people is called into question, displacing with visual encounters that are fraught with memories of an agonizing past the logic that once led through thought to belief.

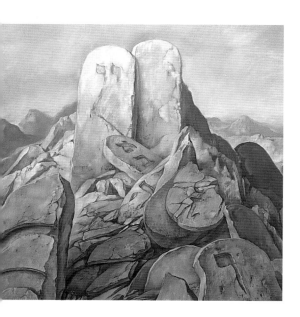

Page 77

Such encounters create a space between painting and viewer that only interpretation can fill. In *Alone*, a citadel of stone molded like a Star of David (or a monstrous fish, or a gigantic rock fragment in the shape of a vessel about to break off from some adjacent shore) seems poised to launch itself into the brooding gloom of a cheerless sea. The hint of a distant radiance that illumines the surface of this floating island, one of Bak's unorthodox "still lives" from nature that more properly might be called "stilled lives," offers no assurance that this potential journey into a liquid wilderness will steer us to any kind of promised land. A leashed energy quivers between the almost defiant star, aimed like a strung arrow, and the ominous sky above. The density of the star, however, more sturdy than its feebler replicas in other of these canvases, does not make it any less forlorn in its solitude. This has often been the initial (though never the final) condition of survival for the Jewish people, the need to emerge from the ruins of their places of worship and habitation: the two Temples, Kristallnacht, the towns and villages and even ghettos of Europe that Jews once called home, the loneliness and wandering that has long been part of their historical pilgrimage.

Without explicitly depicting it, Bak has included in his *Landscapes of Jewish Experience* a focus for this legacy that remains the central spiritual site for the children of Israel, the Kotel or Wall in Jerusalem that together with the shattered fragments of the original Commandments remains the most sacred "Ur-ruin" of the Jewish imagination. But above and behind that holy place, where worshipers seal their prayers, lurk reminders of an unforgotten loss. In *Home*, the temple Wall forfeits its fixed place and becomes a transportable image; the imagination is forced to accustom itself to a strategy of multiple representation. The Holocaust like a palimpsest has imposed layers of further meaning on a once pristine religious iconography.

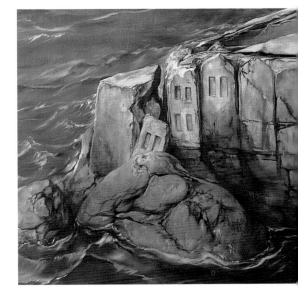

Page 49

The shifting implication of images invites Jews to remember their culture *before* the Shoah, and to absorb what it has done to their culture afterwards. The stones are at once threatening and innocent, rousing a cluster of associations that range from spiritual life to physical death. The wall in *Home* shields a humble dwelling in the foreground while hiding two menacing smokestacks behind. The eye is driven upward and outward in the dual motion that most of these paintings beseech: in a universe of hierarchy, the human spirit soars in the temple of the Lord on a journey toward God; while in the world of the Holocaust, the horizontal [secular] voyage of the Jews, by train or by foot, both eastward and westward, ends in destruction. Meanwhile, the smoke from the crematorium chimneys has infected the soothing appeal of hierarchy, since its ascent is freighted not with the hope of heavenly peace, but a different and far more desolate kind of doom.

The shattered surfaces of sense and form in these paintings, corresponding to a similar fragmentation of post-Holocaust reality, conceal depths of intention, but we are obliged to pursue them with a strenuous tenacity. In *Ghetto*, we have a clear reminder of one personal origin of Bak's art: the *vov* and *gimel* entwined with the cloth Star of David is a signature of that inspiration. Beneath broken slabs of slate a crumbling community lies buried, crushed by a force too heavy to bear. As in all of these canvases, perspective is of foremost importance. There are no natural perimeters here to distract or console the viewer. The locus of attention is the center of the picture, where an underground tunnel beckons us into darkness and confusion. Those attentive to the history of the Vilna ghetto will know that the few resistance fighters who managed to escape must have fled through sewers beneath pavement something like this. We are asked to venture via the imagination on a perilous pursuit into the environs of Jewish fate, with no assurance that what we discover will bring any illumination at all.

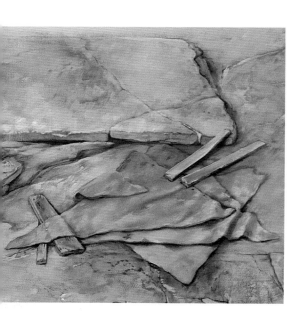

Page 45

This is perhaps the most exasperating dilemma for those who commit themselves to a study of one of the blackest moments in modern history. From this world of stone—curiously, many of the stories which form Tadeusz Borowski's *This Way for the Gas, Ladies and Gentlemen* are taken from a collection whose Polish title is *A World of Stone*—do we extract insight, or absence of meaning? The answer often depends on the *direction* of our encounter, the visual (and intellectual) line of sight that Bak so carefully imposes on his work, so that the eye and the mind fuse into the eye *of* the mind, leaving us unconsciously controlled by a viewpoint that leads from literal to figurative vision. If *Ghetto* plunges us into the depths of Jewish Holocaust experience, paintings like *Smoke* and *Flight* rise to its heights, but instead of trailing clouds of glory, as the romantic poet would have us believe, the spirits of the Holocaust dead have been tainted by an end that the Wordsworthian fancy could not have imagined. Although our vista is expansive in *Smoke* and *Flight* and not constricted as in *Ghetto*, issues raised by the connection to atrocity forbid us from embracing the free-floating masses near the center of these two paintings as metaphors of escape.

The link between Bak's originality and the literature of the Holocaust is once again forged by the parallel concerns of Yiddish poet Jacob Glatstein's "Smoke" and Bak's painting of the same name. Both poet and artist are anxious about the destiny of the Jewish soul after the disaster. Like Bak, Glatstein evokes a graveyard in the sky:

> *From the crematory flue*
> *A Jew aspires to the Holy One.*
> *And when the smoke of him is gone,*
> *His wife and children filter through.*
>
> *Above us, in the height of sky,*
> *Saintly billows weep and wait.*
> *God, wherever you may be,*
> *There all of us are also not.*

Page 61

Bak's sculptured cosmic cemetery, strewn with tombstones, is no New Jerusalem. Like the poet, the painter seeks a proper epitaph for his murdered fellow Jews. But earthly mourning is not enough. What is the role of God in this catastrophe? Do weeping billows in Glatstein's lines reflect divine tears too? "How I love my unhappy God," he exclaims in another poem, "now that he's human and unjust." Implicit in both poem and painting are a riddle and an accusation, since both ponder the truancy of a once omnipresent God. Bak enters a treacherous region of inquiry with his solid stonescape floating on smoke. It images a "miracle" of potential negation, unmoored and adrift in a crippled universe that may have waived the option of personal intimacy with transcendent power—or transcendent love.

The paradox of presence known only through absence, the heritage of all Holocaust survivors who have lost their families, is enshrined in Glatstein's couplet: "God, wherever you may be/There also all of us are not." The missing victims, the missing meaning of their disappearance, the missing God to certify some solace for this awful drama of a blighted people, invade Bak's painting on a grander scale than they do Glatstein's minimalist poem. Blended pinks and blues haunt the atmosphere with an unsettling ghostly glow. The source of light is obscure, but the question *Smoke* raises remains insistent, here and in many of its companion canvases: in a denatured world, disfigured by unnatural death, where is there room for the supernatural? Instead of distilling into spirit, smoke filters into the density of stone—a petrified and petrifying eschatology.

One of the many virtues and challenges of Bak's series is its ability to shape our reaction by altering mood and coloration from subject to subject. If *Smoke* confronts us with a solid mass set in a brooding sky, *Flight* greets us with an evanescent panoply of nomadic fragments from an exploded culture, driven less by light than heat, whose source needs no explanation: a piece of prayer shawl, a striped rag-end of a camp prisoner's

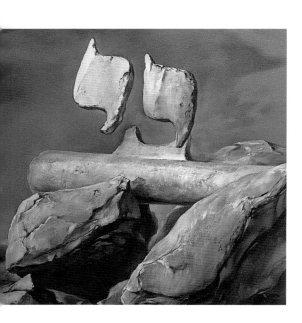

Page 69

12

garment, paper-like facades from ruined Jewish dwellings—all weightless and lacking substance, just the reverse of the heavy image central to *Smoke*. Surmounting these fragile relics are some Hebrew letters, also blown from their context, wafted on air without a text to give concrete meaning to their message. They spell "Shema" ["Hear"], but we are left to wonder who is the spokesman, and who is addressed. Above the buoyant wreckage, the severed twin peaks of the final letter *ayin* [ע] hover like two *yod*s [יי], the traditional designation for Adonai, the Lord. But the signs of God's name have lost their original link to the language of Jewish prayer. Must the alphabet of the covenant be written anew?

The poetry of redefinition that characterizes Holocaust art casts forth this simple word and transforms its familiar appeal into a plea to a silent—or silenced—void. Is this the new *tohu v'vohu*, the "waste and wild" of the post-Holocaust world, a diaspora in the firmament calling for a fresh creation from a previously unimagined chaos? Implicit in the title of the painting *Flight* is a memory bond with an earlier Exodus, but that journey was *toward*, not *from*, a promised land. In its modern guise, what will now fill the space between Genesis and Exodus, between "Shema" and the still unheard divine response? Job's protest provoked a Voice from the Whirlwind. What will succeed this ancient dispute over unjust anguish? Are these remnants of destruction bereft of consolation, doomed to wander like a missile off course in an empyrean desert eternally lacking guidance?

Although habitual frames of belief may have been damaged by the catastrophe, some uncommon ones remain. Certainly the "Shema" can be seen and heard by mortal eyes and ears. "Hear, O Israel," at least, remains a valid cry. Bak's works are a pledge against human blindness and deafness, and the curse of amnesia. Where the Holocaust is concerned, listening is a moral obligation, and remembering a spiritual act. Here, both

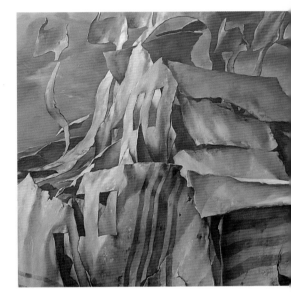

Page 65

13

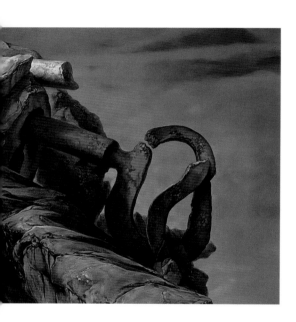

Page 69

unite into forms of seeing, first the literal viewing that we call sight, then the inward turning, the deepened thought we name insight, born of an active interplay between intellect and emotion. Art projects images that assume a life of their own and gain the special immortality that is granted to secular expressions of genesis, the act of creation. *The Landscapes of Jewish Experience* prompt us to think and to rethink that experience, reminding us that multiple viewpoints cannot merge into a single interpretation. The word "Shema," in its source and its target, embodies many voices. The ancestral flight from slavery to freedom mutates into a journey from atrocity to an uncertain destination. We now have two Jewish sagas to absorb, one starting with Creation, the other with Destruction: whether this is an inspiring or a desolate summons (or both) remains a central issue of these paintings.

That tension is reinforced by the diptych called *Hidden Question*, where the mystery of divine purpose *and* presence is increased rather than solved by the rusted or broken keys that comprise a central motif in these adjacent paintings. The question mark in the handle of one key is balanced by the zero in the handle of the other, neither especially encouraging to our quest for meaning in a once divinely ordered universe. If we read from right to left, as Hebrew requires, then the stone arch burdening and shadowing the building—perhaps a synagogue—on the right seems shattered and dispelled in the canvas on the left, creating a buoyancy of weight and hue that suggests a casting off of bonds. Yet the name of Adonai, the twin *yods*, appears in both, a clue or an enigma that lingers above the Lord's temple but remains symbolically separated from the language of His people, the letters that allow a dialogue between them and insures a nurturing and covenantal role for their God.

The place of worship, or human dwelling, is restored intact. Jews can gather there to renew their bond and to acknowledge the revival of their religious community. But in his visual

inquiry into the state of post-Holocaust Jewish life, Bak refuses to simplify by celebrating partial victories. The name of God still perches on the stone fragments that once fused neatly into the Tablets of the Law, and the blank windows on the building in *Hidden Question*, shaped like these Tablets, remind us now of the need for a reinscription of faith. As the eye moves from right to left and back again, between a brooding darkness and a brightening day, we have an uneasy sense that before we can begin to solve some of the spiritual riddles raised by the murder of European Jewry, we must try to redraft our questions by plunging them into a new crucible of doubt.

The parallel masses in *Hidden Question* refuse to coalesce into a comfortable decree. The natural forms that crowd most of Bak's paintings are loath to disclose their mystery. The viewer is faced with the need for redefinitions in nature that include the urge to refashion both the human image *and* the divine. Nelly Sachs captures this shift in perspective in a poem that seems a verbal equivalent of some of Bak's visible intentions:

> *Night, night,*
> *Once you were the bride of mysteries,*
> *decorated with shadow-lilies—*
> *In your dark glass glittered*
> *the illusions of those who yearn*
> *and love has brought forth its morning rose*
> *to bloom for you—*
> *Once you were the oracular mouth*
> *of dreampainting, mirror of the world to come*
> *......................*
>
> *Night, night,*
> *Now you have become the graveyard*
> *for a star's dreadful shipwreck—*
> *time dives speechless into you*
> *with its omen:*
> *The tumbling stone*
> *and the flag of smoke.*

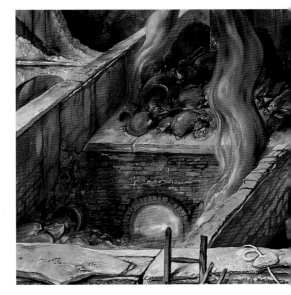

Page 105

15

Those very omens dominate the paintings in this series. Just as there was an era when remembered pain was only the space between health and hope, so once night was merely an interval between twilight and dawn. But no more. Nature—and mankind—have been immersed in the murky waters of the Holocaust, leaving a residue of spiritual indecision virtually impossible to cleanse. Older rituals of purification are equally stained.

The most mystical—and "difficult"—painting in Bak's series is *Pardes*, an invitation to interpretation that mimics the sages of the Cabala. *Pardes* is rich in allusion: it is the Hebrew word for orchard, taking us back to the scriptural period of creation; its four consonants in Hebrew [**פרדס**] represent a devowelized cognate with our word paradise, with all the ironic overtones carried by that term in a post-Holocaust society; and its individual letters refer to four methods of Biblical exegesis—literal, allegorical, theological (or homiletic), and mystical. The painting thus codifies our own journey through the *Landscapes of Jewish Experience*, with its multiple challenges to the eye and the imagination to consider the impact of the Shoah on traditional forms of worship and belief.

"The alphabet is the land where the spirit settles and the holy name blooms," Nelly Sachs announced in a note to one of her brief dramatic pieces. Bak's *Pardes* draws on a similar recondite conundrum, though with far less certitude. With its downward perspective, the painting reveals two wooden tombs with the tops peeled off in the shape, once more, of the Tablets of the Law. They are divided into two segments, making four in all, each fronted by its own door, each door in turn surmounted by a Hebrew letter: P,R,D,S. They invite our entry and our interpretation, though the doors close progressively as we move from right to left, emphasizing the difficulty of analysis as time and memory proceed from the simple to the complex, from creation to catastrophe. The last door is nailed shut by two

Page 61

crossed pieces of wood in the shape of an X (another recurrent motif in these canvases), just below the "S" which signifies the Hebrew word Sod, or secret. Enterprising viewers may note that a slight twist of the X to right or left yields a crucifix.

Bak shares with Nelly Sachs the belief that meaning must be rebuilt from the ashes of annihilation, saving from the rubble of mass slaughter the murdered word. Sachs called the alphabet "the lost world after every deluge. It must be gathered in," she argued, "by the somnambulists with signs and gestures." And *Pardes* does indeed appear to be a dream landscape, until we accept the imaginative journey through its Kafka-like corridors that carry us from legend to reality—or from nature to cabalistic lore. As we learn to read the signs and gestures of this art, we find ourselves shifting between myth and history and the paradoxes they engender. The Tree of Life in a garden called Paradise had a fellow whose fruit gave birth to death; while the fiery furnace at the end of the voyage, in mystical tradition the origin of the soul, was in our age the greatest source of Jewish havoc known to man.

Smoke drifts toward the tree in a meeting of natural forces, leaving us wondering which will prevail. The Jewish narrative of creation moves from chaos to form, from silence to speech and illumination: "Let there be light!" The Jewish narrative of disaster, the story of the Holocaust, migrates from form to chaos, from speech to silence—and the darkness of extinction. The intellectual, philosophical, and artistic landscapes of modern Jewish experience inspire a quest for reconciliation, but furnish no guarantee of a successful closure. The problem is that familiar images (like familiar expressions) of consolation cannot cure the wounds inflicted by the loss of European Jewry. A return to the innocence of Eden (or the purity of words) is a futile venture. Nelly Sachs captures the dilemma concisely in a few lines:

Page 105

17

But here
always only letters
that scratch the eye
but long since become
useless wisdom teeth
remains of a dead age.

As it wanders through the gateways and labyrinths (or scrolls) of the middle zones in *Pardes*, can the imagination rekindle a celestial spark and restore vitality to that dead age? The furnace at the end of the pursuit glows with the holy intensity of divine mystery—but also with the blazing wrath of the consuming flames of Auschwitz. Does it contain what Nelly Sachs named "the awaited God," or the demon of mass murder? Are we gazing at an altar—or an oven? Are the fragments in its vicinity remnants of sacred vessels—or human skulls? The images before our eyes compel this kind of constant query, as we re-enact the need to restore spiritual purpose to a shattered world, while discovering through our very search the possible folly of our efforts. The ladders in the painting invite entry and offer escape, matching the inner voyage that divides our choices between peril and hope. If we allow the intricacy of Bak's images to invade our lives, we find ourselves exploring a realm both sinister and benign, a domain of deathlife or birthdeath that requires a new vocabulary such as this, as well as a fresh catalyst for perception.

A favorite term in Nazideutsch—a special language devised by the Germans to conceal and express their plans for the Final Solution—was *ausrotten*, to uproot or extirpate, and by association, to exterminate. "Uprooting," of course, is part of the history of the Jewish people, and Bak exploits this dual usage to inspect that experience in past and present. The central motif in *Family Tree* and *Destinies* is a tree severed from its trunk or ripped from the earth, but in neither instance has this violation of nature led to its total death. Less a miracle of renewal than a

Page 99

18

stubborn resolve to stay alive, the continued survival of the Jewish people is confirmed in the small shoots that spring from the base of the trees even as the upper trunks are sheared away. Hidden amidst the fading golden leaves shaped like Stars of David in *Family Tree* is a rising limb with two vertical branches, a cruciform echo that the murder of the Jews has been a calamity for Christianity too. The landscape of Jewish experience shares its terrain with its co-religionists, though responsibility for the atrocity is unequally divided. The degree to which the Christian spirit may have been morally tainted by the physical uprooting of the Jews is a muted theme in several of these paintings.

The basic question is whether the natural principle of growth that is native to life can be stifled by enemies bent on wrecking it. In the past, the roots of the children of Israel have shifted between a fixed and a portable status, and these two paintings capture those twin options, that have not changed through millennia. In *Family Tree* the trunk stays anchored to the soil, while in *Destinies* even the roots have been torn from the earth, and seem fated to be transferred to more fertile ground. In *Destinies*, some leaves are fashioned like metallic Stars of David, lifeless and even reminiscent, with their shield-like sheen, of the violence that destroyed the people who were forced to wear their originals as emblems of shame. The amputated trunk is supported by crutches of uncertain origin, hardly a happy image of the triumph of survival. Yet the lingering roots have not withered, their remaining vitality yearning for transplantation, by awaited men if not by Nelly Sachs's "awaited God."

Can life be repaired or replenished by animating the erosions of death? Looming in the foreground of *De Profundis* are two vacant gravesites not only shaped like giant Tablets of the Law, but containing their fractured remnants. An arid, Negev-like terrain stretches into the distance. But the adjacent paintings of trees with roots intact, together with our sense of how parts of the Negev have been cultivated in modern Israel, conspire to

Page 95

remind us of the rhythm of loss and renewal that has allowed Jewish life to be propped up, like the sides of the tombs in *De Profundis*, in the very jaws of extinction. The force of ancient laws may seem to perish, like the splintered letters of the Commandments in this painting, but Bak refuses to seal the crypt and with it all hope for a thriving Jewish existence. Some meager emblems of possibility survive, though as with those who were still alive when the Holocaust drew to a close, there are few occasions to rejoice in Bak's visions, and much cause to mourn. A piece of ladder at the painting's edge hints at some chance of flight, while a narrow road winding toward the horizon speaks of a journey still to be taken. But the burden of memory, the personal and ritual loss, dominates the scene, as the broken contents of these mausoleums invite us to consider whether the price we pay for the anguished passage from grave to growth is too high.

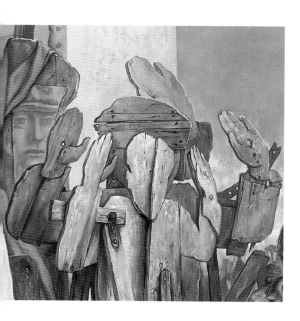

Page 37

Bleakness is a permanent legacy of mass murder, the frame from which all post-Holocaust art must emerge. If most of Bak's landscapes are dreary, however, the fault is history's, not his. One of the many virtues of his work is a resolute refusal to melodramatize or sentimentalize his art. We learn nothing of the "agony" or the "dignity" of dying in these paintings, all but three of which introduce the muted theme of the annihilation of European Jewry through the absence of human figures. Only three contain vestiges of mortality, but even they are associated with art more than with life, and the first and the last, *Self Portrait* and *The Sounds of Silence*, enclose the series with some vital questions about the limits of representing a catastrophe like the Holocaust. Almost midway between the two is *Nuremberg Elegie*, a modern variation on Dürer's famous etching *Melencolia I* of 1514, with its somber female figure meditating on the ruins of time—though critics have never agreed on the exact sources of her dismay. But rather than illustrating the anxiety of influence, Dürer's bequest to Bak, the intermediate role of *Melencolia I* suggests the influence of anxiety, the loss of continuity between two artistic visions and traditions,

owing to the intervening disruption of an atrocity that Dürer could not have imagined and Bak cannot escape.

Self Portrait is a portrait of the artist as a young boy, though the child will turn out to be father to the mature man. Among the many crimes committed by the Germans against the Jewish future was the murder of more than a million helpless children. The initial painting in Bak's series is a vivid reminder of the deathlife that is a vexing if paradoxical birthright of that crime: no one's survival can be detached from the loss of someone else. The boy sits in a sack as if emerging from a cocoon of death, though only those privy to Bak's personal ordeal will be able to grasp the allusion, which seems allegorical but is not. Sent with his son from the Vilna ghetto to a labor camp nearby, Bak's father hid him in a sack, which he then dropped unobserved from a ground floor window in the warehouse where he was working. Through a prearranged plan, the young Bak was met by the maid of a relative who was raised as a Christian, and taken to a safe haven. The memory of that moment turns his expression inward in the portrait, making him virtually oblivious to his external environment.

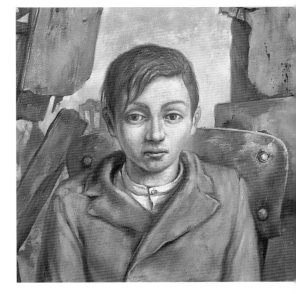

Page 37

But the viewer is not. Through one of the great ironies of Holocaust history the other child in this picture, a casualty of the Warsaw rather than the Vilna ghetto, immortalized through the best-known photograph to outlast the catastrophe, is far more familiar to us than is the image of the living boy. With his hands raised, fear and confusion in his eyes, he is imprinted on what appears to be the remains of a primitive wood and canvas surface as the archetypal victim, from whose existence the artist-to-be will inherit an important influence on his own version of reality. *Self Portrait* thus contains portraits of several selves, including our own, since a central motif of the series to which this painting forms the introduction is the question of how a post-Holocaust era can absorb such a vast atrocity without abandoning the challenges of life, or the summons to art.

Primo Levi has written in his memoir of Auschwitz that death begins with the shoes. He meant that a worker whose feet were not properly protected soon lost his mobility, and hence his chance for survival. The pair of empty shoes so prominently displayed in *Self Portrait* awaits an occupant. The boy with his hands raised no longer has need of them, as his feet fade from flesh to painted wood. The feet of the child who was Bak are still hidden in the sack, not yet ready to pursue the arduous journey that will lead from life through death to art. Who indeed is qualified to undertake that voyage? The dazed look on the boy's face betrays only a dim perception of what lies before him.

Unlike the missing slipper that fit Cinderella and turned a scullery maid into a happy princess, these shoes are not the stuff of fairy tales or myth. Are they emblems of the awaited artist, who unlike Nelly Sachs's "awaited God" has the painful task of finding shapes for the chaos of atrocity and thus rescuing it from oblivion? The child-artist is here surrounded by mementoes of disaster, not only "The tumbling stone\and the flags of smoke" of the poet's imagination that crowd the edges and corners of the picture, but also the blank pages strewn at his feet that must be filled with the story of a world aflame and a people destroyed. The small stones holding them down commemorate death in Jewish tradition, not creation; yet if *Landscapes of Jewish Experience* heralds anything, it is that the Holocaust has bonded death with creation now and forever, *l'olam va'ed*.

That world aflame hovers not only in the recesses of our mind as we gaze at this painting, but also as part of the distant vista itself. At this point in his career, the boy-artist sees less than his audience, though by the end of the series art will transform our vision and his. Indeed, traces of future paintings tempt us to see *Self Portrait* as a literal prologue to the act of creation. The boy sits on a rocky expanse resembling the uninhabited stone promontory of *Alone*, while across the water the

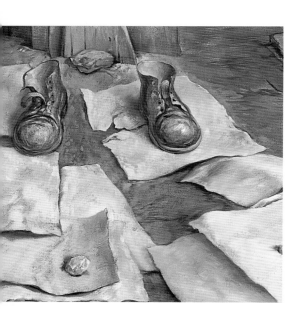

Page 37

22

smoking stacks of a vessel foretell the crewless stone ship of *Voyage*. And the giant canvas in the upper left corner of this painting, still innocent of any brushstroke, augurs the destiny of the artist himself, who will grow up to create the *Landscapes of Jewish Experience*.

But first he must submerge himself in the details of history and the techniques of art, and develop his intensely personal view of how they intersect, while honoring both. Imagining precedes imaging: the artist must witness his own life, and that life in its time, before he can merge them in a larger vision reflected by the images of his art. The choice of Dürer's *Melencolia I* as a link—or rather, a broken link—between past and present is full of dramatic portent. Bak's *Nuremberg Elegie* is a *Melencolia II*, a sequel to the portrait of a winged and angel-like figure musing on the sadness of the world. Late medieval and early Renaissance thought crowded the imagination with ideas of discovery and progress, but the brooding intelligence could be overwhelmed by the contrast between these possibilities and the misery wrought by the ravages of war, epidemics, and the quest for power, to say nothing of the religious doubts raised by the incursions of science and technology. The duty of the artist to encompass these contradictions can prove to be a burdensome chore. Dürer gathers into his engraving a dense allegorical clutter of technical apparatus that leaves little room for expressions of the natural and spiritual world. The modern mind has minimal difficulty sympathizing with this dilemma. But Bak's *Nuremberg Elegie* is no simple imitation of its predecessor. The city whose rallies and trials began and ended the reign of the Third Reich did not have for Dürer the sinister ring that it carries for a contemporary ear. The title is a terse reminder of how the Holocaust has changed the resonance of individual words, even proper nouns.

Its elegiac impact has also altered the content of what we mourn, and how. A popular Renaissance theme was the mutability of time, symbolized in Dürer's engraving by the presence

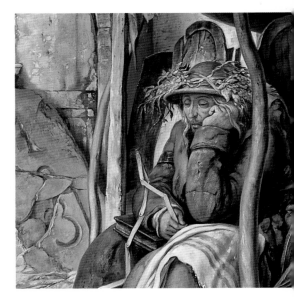

Page 83

23

of an hourglass. Erwin Panofsky has described the Dürer work as follows: "The winged Melancholia sits in a crouched position in a chilly and lonely spot, not far from the sea, dimly illuminated by the moon. Life in the service of God is here opposed to what may be called life in competition with God; peaceful bliss of divine wisdom, as opposed to the tragic unrest of human creation." But the Holocaust is not a story of the tragic unrest of human creation. It transmutes mutability into annihilation. The atrocity of mass murder has no tragic dimension, its barbaric destructive power temporarily thwarting the basic impulses of the creative urge. Despite its sporadic gloom, the Renaissance mind laid the groundwork for an age of Enlightenment that still inspires the expectations of the democratic world order. Panofsky points out that Dürer's *Melencolia I* is balanced by his serene and reverent "St. Jerome in his Study," utterly removed from the radical prospect of an "awaited God." Such repose never enters Bak's post-Holocaust landscape of Jewish experience.

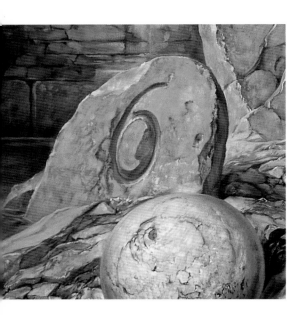

Page 83

Instead, Dürer's brooding angel is replaced by a morose helmeted soldier, surrounded by the concrete images—hardly allegorical—of the modern disaster. At his feet lie the brightly-colored but tattered remains of what once was a rainbow, sign of a renewed covenant and the deluge's end. The failure of that promise is linked to the default of another pledge of divine origin, perhaps Bak's favorite image, the Tablets of the Ten Commandments, which have tumbled from their stable site. They lie like gravestones askew with some numerals still visible, though unlike the number square in Dürer's etching whose columns all add up to 34, Bak's single digits, especially the "6," bear no mystical or magical overtones. The sixth commandment, "Thou shalt not murder," has resulted in the slaughter of six million. It is as if the murder of European Jewry has stripped the mystery from existence, leaving only the barren truth of a spiritual wreckage whose import is all too clear. The

signs that earlier intensified life by filling it with symbolic meaning crowd the canvas divested of their ancient complexity. Is it any wonder that the artist in the guise of a soldier, offspring of violent conflict, sits sunk in such meditative gloom?

In the place where the Tablets formerly rested stand and lie two meager candles, their wicks barely flaring, rising into petrified plumes of smoke, etched in the stone. One plume points toward the broken wooden arc that once contained the colors of a rainbow; the other aims at the crossbar of a truncated crucifix, backed and topped by a brick chimney. The physical assault on spiritual truth is reinforced by the military garb of the seated human figure, as well as by the splintered crucifix, which now resembles a gallows. Across the man's knees a Jewish prayer shawl lies draped, while in his hand, like a writing instrument, he holds an unfolded carpenter's rule, as if he were wondering what message to inscribe on this holy relic.

The single images only create the appearance of complexity; they remain separate and unintegrated in a disintegrating world. Yet paradoxically, through the technique of juxtaposition, the artist has achieved an astonishing unity in his organized grouping of fragmentation. Man is no longer a transparent eyeball, as Emerson would make him, reading spiritual meaning into the signs and symbols of nature. As a consequence of mass murder those signs and symbols have grown tainted. To be sure, in Bak's paintings the eye is in constant motion, but as a source rather than a medium for insight. And its main activity is to struggle internally through the brambles of displaced certitudes.

Initially, a chief incentive for both artist and audience was the desire to perceive with visual fidelity the forms of physical and spiritual reality. But Bak has replaced this priority with the need to *re*-perceive. What we see *is* and *is not* what it once was: smoke, flame, candle, star, crucifix, rainbow, and even the number 6.

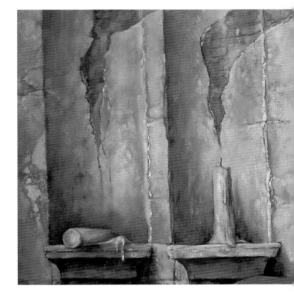

Page 83

The Holocaust has smitten history, memory, language and art. *Nuremberg Elegie* invites us to ponder this colossal loss; but it also bids us consider what might be reclaimed from the ruin. The great musical requiems are not always mired in sadness, but often soar to glory.

In a moment of uncanny prescience, Dürer recorded in his papers a sentiment that might have given birth to the final painting in Samuel Bak's *Landscapes of Jewish Experience*: "A boy who practices painting too much may be overcome by melancholy. He should learn to play string instruments and thus be distracted to cheer his blood." Bak's *The Sounds of Silence* pays unwitting tribute to this measured advice, though its somber mood might curdle the blood even while wishing to cheer it. This last canvas leaves us with an unanswered question, marked by the large "X" that presides over the scene: Does art finally triumph over atrocity, or does atrocity as we have known it in our time in the end suck art back into its insatiate maw? Is the art of hearing too expensive a luxury, now that our eyes have been stunned by the frightful sights before us?

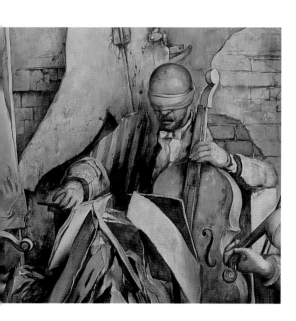

Page 117

In this culminating canvas of the *Landscapes of Jewish Experience*, Bak grants to music, the purest of the arts, a dubious future. Just as *Nuremberg Elegie* comments on Dürer's *Melencolia I*, so *The Sounds of Silence* seems a grim scrutiny, though in another medium, of Olivier Messiaen's "Quartet for the End of Time," a piece composed and first performed in a POW camp during World War II. With the sky blocked by a gigantic chimney rising beyond the frame of the picture, this string quartet, resembling an enfeebled modern version of the Four Horsemen of the Apocalypse, mimics harmonies muffled by a bizarre acoustics of death. One member is blindfolded, still wearing his striped inmate garb; another is masked; and a third appears to have lost his fleshly contours and is sketched instead on the surface of a block of stone. The cello is blue, the viola discolored, small wonder when we recall the abuse of music in

Auschwitz, where some prisoners were forced to play while others were marched to work. The impulse to art has survived its humiliation, but the appeal of the performance, like the diminished worth of the wooden angel-wings shorn of divine vitality, is curtailed by the crumbling remains of a papier-maché ghetto lying at the players' feet.

This is Samuels Bak's final version of the deathbirth of art. Just as in *Self Portrait* the future of the boy-artist has been certified by the fate of the boy-victim from the Warsaw ghetto, so here the outlook for music, and by extension for all art, is shaped—or more exactly, distorted—by the rubble of mass murder. But this series has not only concerned the deathbirth of art; equally vital has been the issue of the deathbirth of faith. The history of the Holocaust has dismembered both, art and faith, leaving us with the dual dilemma of retrieving from the ashes of this monumental destruction a phoenix of beauty and a phoenix of belief. Legend and human need coalesce into a new fruition, as the "human form divine" sheds its ancient trappings and redefines its perpetual quest for fresh identity and meaning.

Robert Frost once noted that art comes not from grievances, but from grief. Bak begins his series with the personal dimensions of this grief, the loss of the city of his childhood, the Vilna that was the jewel of intellectual, religious, and artistic inquiry in the diadem of eastern European Jewry. He then spreads that grief to include the disgrace and dispersal of the tokens and symbols that lend vigor to the Jewish imagination itself. In the vestibule of annihilation, the setting for *The Sounds of Silence*, with its looming brick chimney and thin smokestack in the distance, no Star of David shines, no tallow flames from the memorial candle. Perhaps, for Bak himself, the rituals of belief have been replaced by the equally demanding rituals of art. His paintings are his acts of devotion, his tributes to remembrance. At the risk of irreverence, one might argue that the artist as creator is a human reflection of divine intention, filling the void of

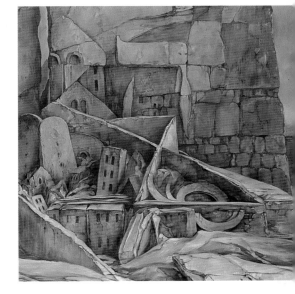

Page 87

27

a blank canvas with forms that populate a living universe of their own. *The Sounds of Silence* taunts the ear with an unheard melody we are forced to invent, one appropriate to the legacy of atrocity that inspired it. And so with the *Landscapes of Jewish Experience*: their images haunt the imagination, challenging us through a veil of visual silence to change their mute provocation into the language of an inner speech.

Page 37

Paintings
and
Commentary

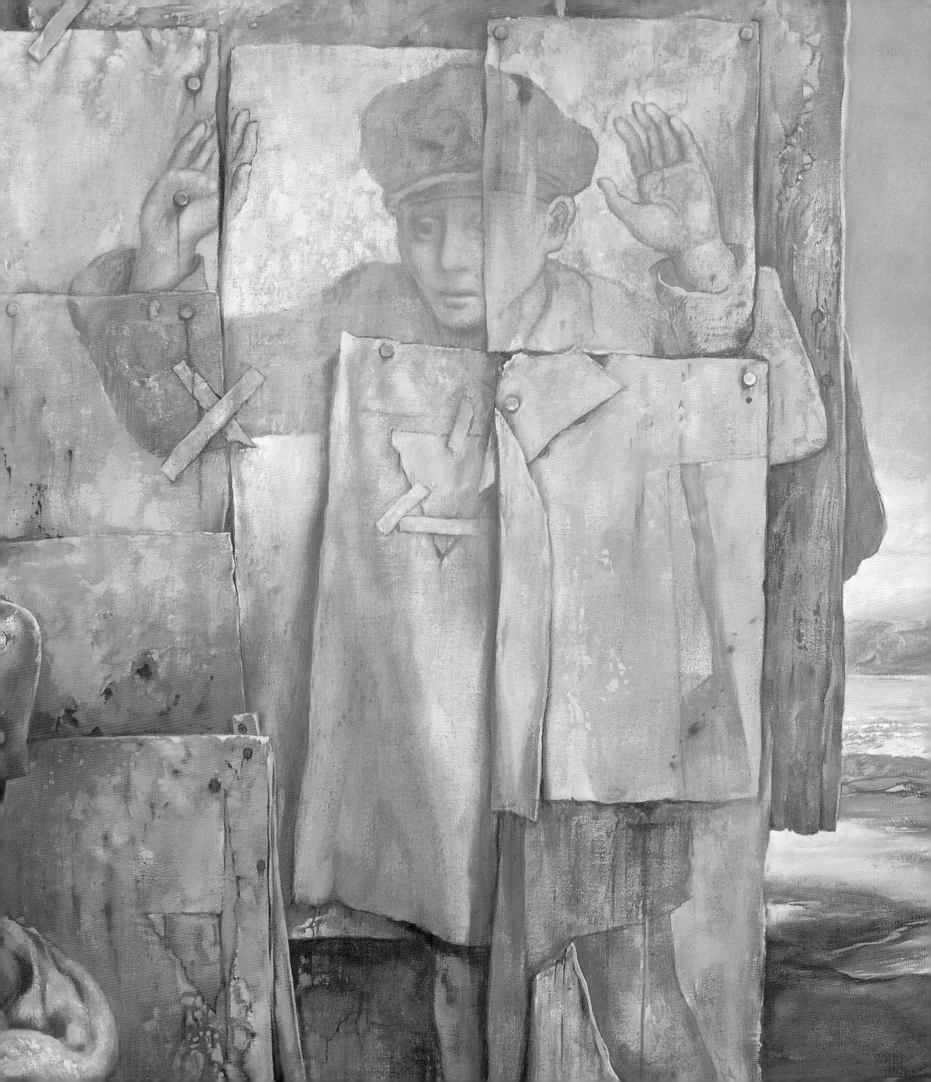

1. Self Portrait

The content of this painting violates our surmise of what such a title usually intends. The boy who grew up in pre-war Vilna with an intact family is not the same as the one who survived the catastrophe remembering a murdered father and a ruined community. The Holocaust has shattered the notion of a unified self. Indeed, the center of the picture is dominated not by the face of the living boy, but by the replica of a dead one, taken from the most famous photograph to emerge from the disaster. It reveals a frightened child, hands raised, being led from what might have been a hiding place in the Warsaw ghetto. His is a "counter-portrait," though the two likenesses are really inseparable, since the fate of the boy who was Bak is intimately linked to the doom of the victim whose image is imprinted on a crude assemblage of panels and canvas. On the left are some wooden cutouts of the posture that will be reproduced, the bullet-holes in the palms changing on the portrait into the stigmata of a crucified Christ. One of the muted themes of the entire series is the question of Christian responsibility for the destruction of European Jewry. The boy has only to straighten his arms to assume a cruciform position. At his elbow joint are two pieces of wood in the form of a tilted cross, though their X-shape also suggests the mystery of iniquity and—as a Roman numeral for 10—the defilement of the ten commandments.

Among other challenges, these paintings invite us to read their signs as complex visual images of strands of atrocity that will be rewoven into a tapestry of art. The rhythms of creation must somehow absorb the jagged heritage of loss. Like the ghost of Hamlet's father, the figure of the dead boy with raised arms imposes a blessing-curse on the seated child: "Remember me!" Whatever he achieves in the future, the living boy will be haunted by the memory of all the lost childhoods, including his own. The implement in his hand, presumably the shaft of a paintbrush, is a harbinger of his vocation, though Freudian commentators might also want to see in this detail a bond between creative and sexual energy. Behind his right shoulder loom a large vov and gimel made from scrap lumber, initials of the Vilna Ghetto, replicating tinier versions of the same letters that appear on the Star of David on the other boy's breast.

The boy himself gazes at us like a post-Holocaust Mona Lisa, though his somber mouth betrays no hint of a smile. Instead, both eyes and lips bid us to consider the violent past that has etched itself onto his inner vision. As this bitter seed sprouts and blooms, what role will it play in the later creation of the *Landscapes of Jewish Experience*?

The viewer is also invited to reflect on a sturdy pair of empty shoes, all that remains of a vast population of Jews whose bodies have been turned to ash. Who will wear them now, and how will he or she carry on the tradition of Jewish memory once transmitted by their former occupants? This question is deepened by the small stones in the right foreground, holding down blank sheets of paper, reminding us of how the Holocaust has disrupted familiar Jewish customs for remembering the dead. Are these empty pages part of a Torah scroll at the boy's feet, and with what text will they be re-inscribed? Belching smokestacks in the distance, as well as hints of a community in flames, summon us to a vista of crimes of unimaginable dimensions, crimes whose impact will be portrayed in the subsequent paintings of this series.

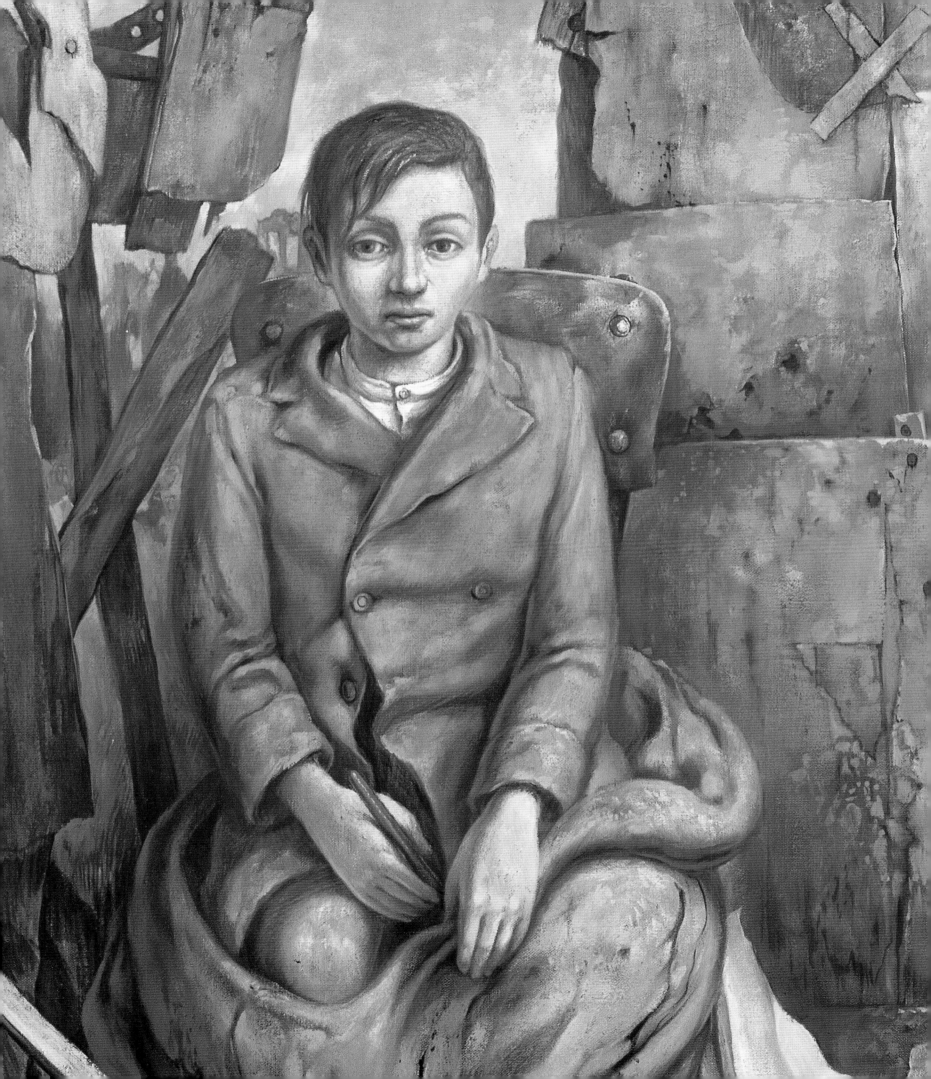

Self Portrait
1995-1996
160 x 200 cm
Oil on canvas

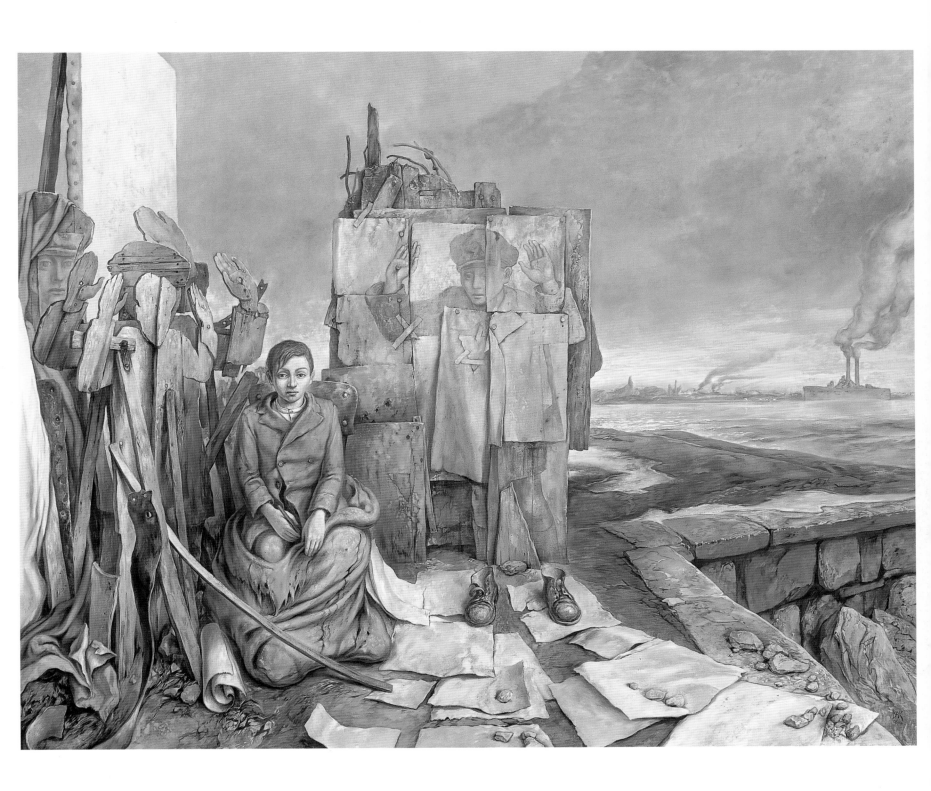

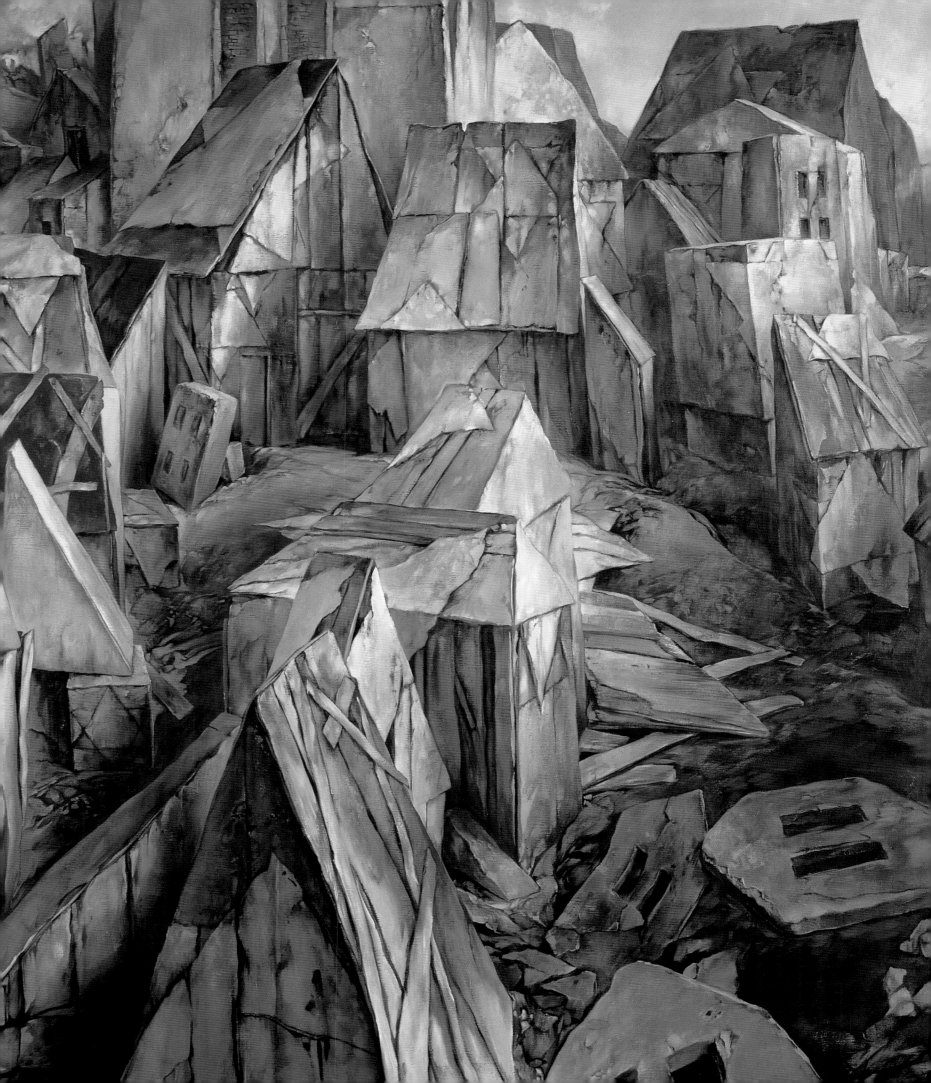

2. Under the Star

A slanting late-afternoon sun gilds the angular facades of a vanished Jewish community. The lower half of a wooden Star of David, supported by a flimsy scaffolding, presides over the scene. In both coloration and form, the spectacle resembles a cubist canvas, though all the contours have not yet been flattened into thin planes. Buildings block the horizon, while in the distance smoke spreads across the golden sky, staining its beauty without entirely effacing the source of light that burnishes the picture. Looming in the background, adjacent to the Star, is an abandoned synagogue, its tablet-shaped windows staring at us like vacant eye-sockets. Scattered on walls and sloping roofs are triangular fragments of further Stars of David, confirming that we are looking at the remains of one of the many Jewish ghettos consumed in the Holocaust. The ramshackle edifices seem on the verge of collapse, though the rickety Star may testify to the possibility of a fragile survival. Although its top is chopped off by the frame of the painting, the vertical thrust of the Star, together with the gabled roofs below it, leaves some space for escape in the imagination. A teetering citadel of square stones, much like children's blocks, rises behind the Star, perhaps a melancholy cue to the doom of the children who once played in these shattered homes.

Under the Star
1992
160 x 200 cm
Oil on canvas

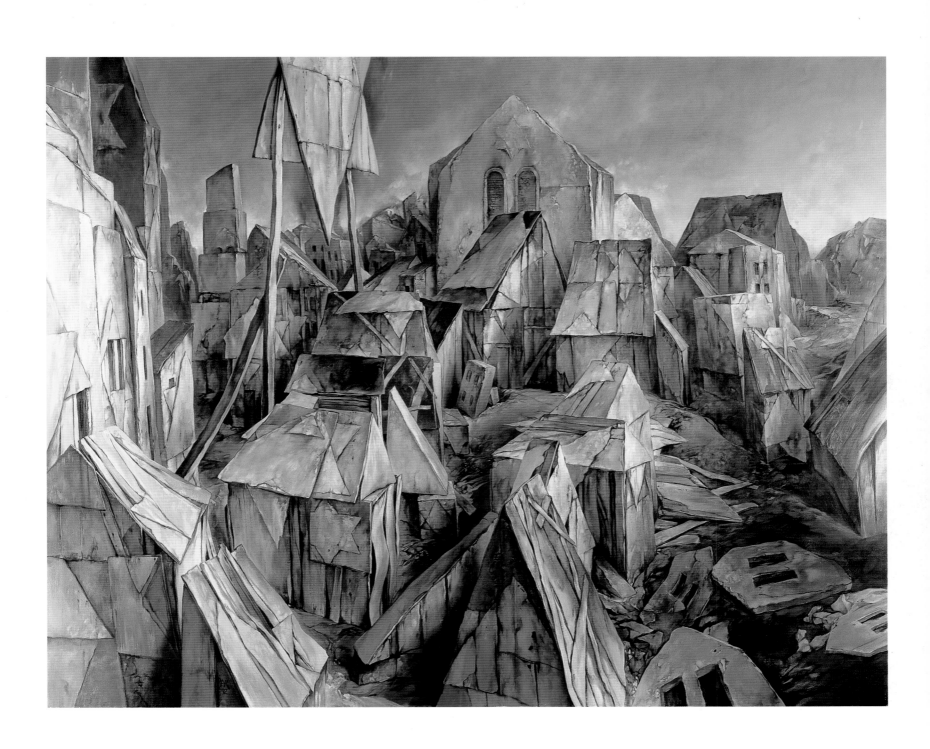

3. Ghetto

In *Ghetto* neither eye nor imagination has any way of escape. The horizon has disappeared from this landscape without vistas; all signs of nature have vanished too. Holocaust history does not proclaim its message; we must excavate what we can from the ruins. Sheets of slate have been moved aside as if from a tomb, to reveal a star-shaped scar leading into an obscure tunnel lined with the facades of crumbling structures—the former ghetto. Like forlorn Dantes without benefit of Virgil, we are forced to pursue the fate of European Jewry into the threatening depths below the inert stone surface, following a narrow corridor between lifeless brick walls. But our obligation is clear: memory and commemoration allow no other route. Even the pale yellow cloth from Stars of David once worn on the victims' breasts points toward the ominous entry-way, as if all the energy in the painting were focused on this journey into the heart of Holocaust darkness.

And what awaits us at the end? Tiny glimmers of reddish light, like the eyes of demons, or the openings of twin crematorium ovens, beckon from the abyss, an unholy glow that evokes for us the fate of a people. We have the choice of moving the slabs of stone back in place and burying them forever, or accepting the strenuous duty of mining the evidence of their demise and keeping it steadily in consciousness for our own and future generations.

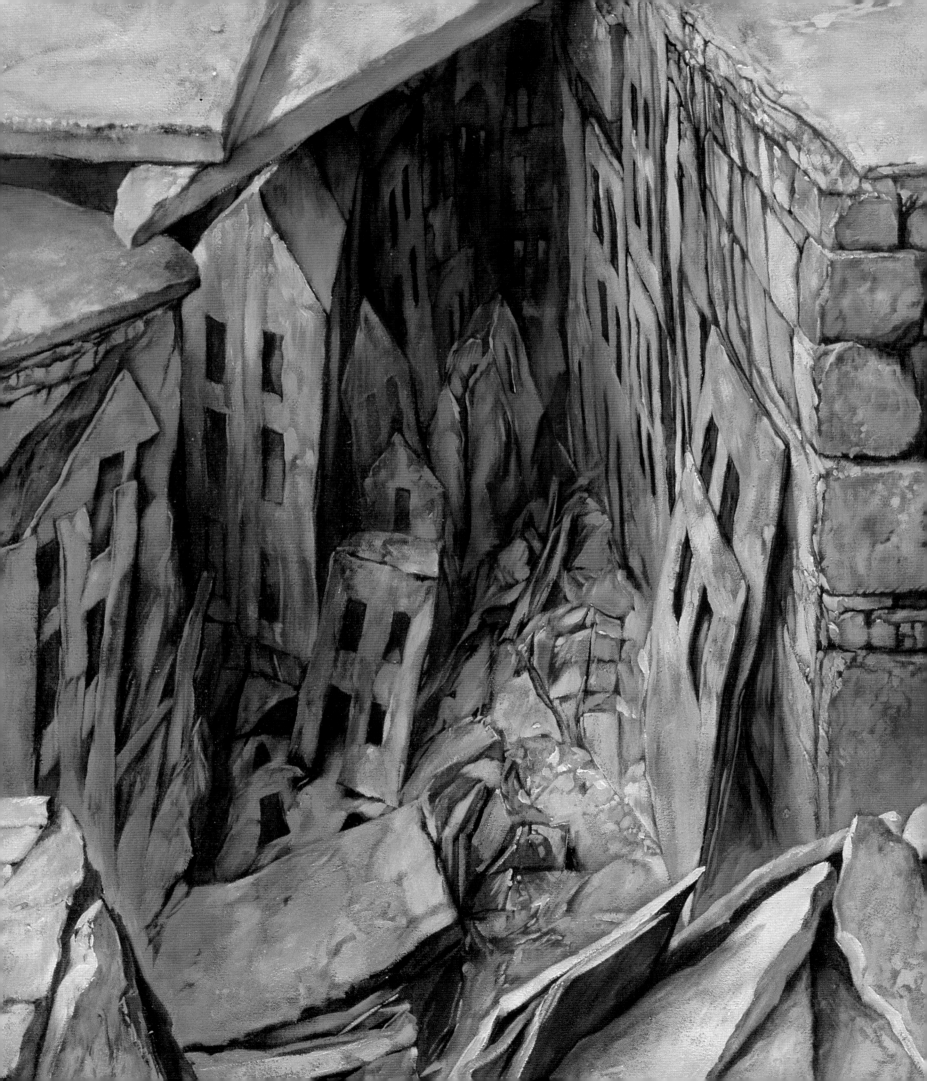

Ghetto
1996
160 x 200 cm
Oil on canvas

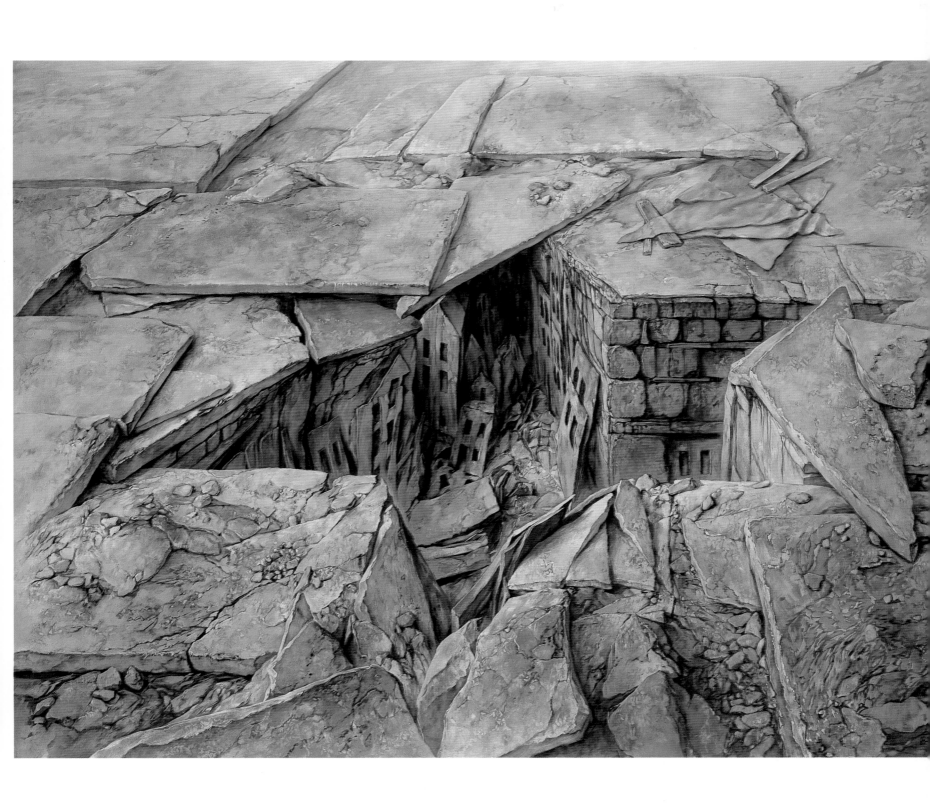

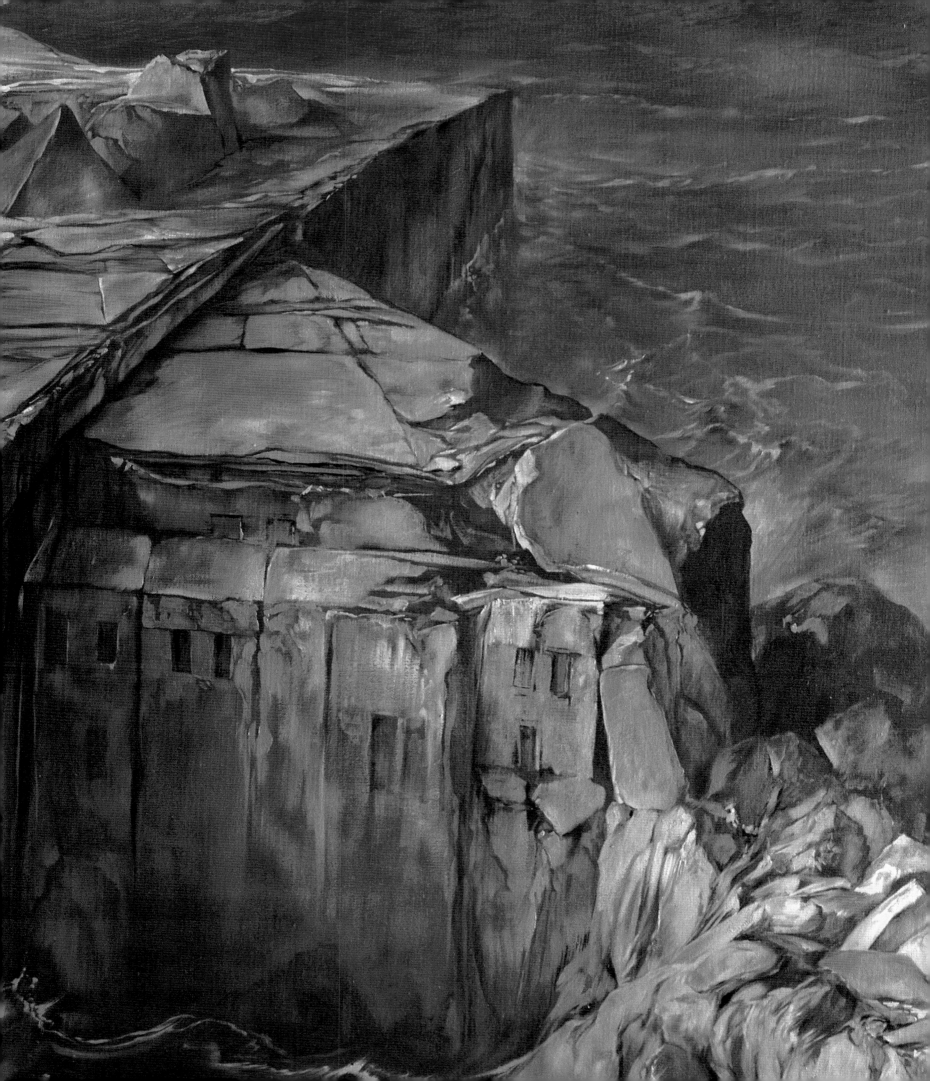

4. Alone

This is probably the grimmest painting in the entire series. Like an abandoned Alcatraz, a giant stone Star of David is poised to launch itself toward a hostile horizon, surrounded by an uneasy sea. A lowering cloud lurks above this petrified behemoth, that seems about to break off from an adjacent shore. Nature does not favor the voyage, as dark churning waves pound the "ship's" crumbling bulwarks. Peeling concrete veneers reveal remnants of human dwellings, prompting us to ask who will repopulate this modern ark of Jewish destiny in the future. And what spiritual course will they pursue? An unspecified source of light momentarily bathes this crewless vessel with a faint golden glow, though it does not change the solitude of the scene. The only cargo is a cluster of small houses, sole tokens of their murdered tenants.

The question of options is raised by the very substance of Bak's art. The Star of David motif, for example, recurs throughout the *Landscapes of Jewish Experience* in various materials (wood, cloth, stone) and in different guises (upright and prone). This strategy challenges the viewer to renounce simple corollaries between image and meaning or content and form and to embark instead on the floating contradiction that is the subject of this painting.

Alone
1995
160 x 200 cm
Oil on canvas

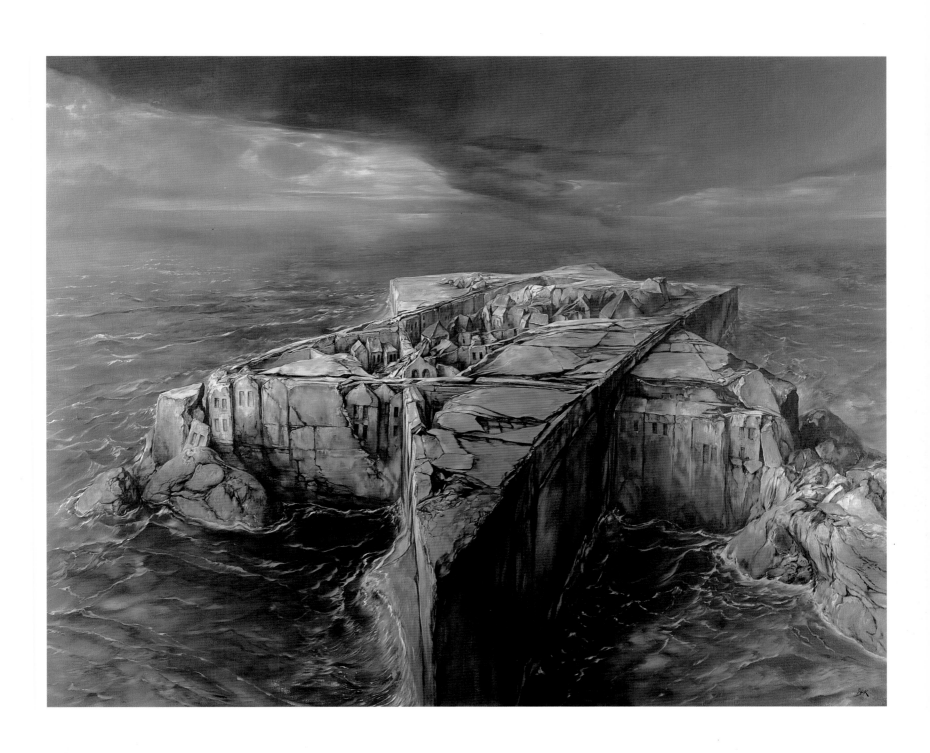

5. Journey

Another floating contradiction, this genuine vessel points toward a less ominous horizon than the one in *Alone*. Through a sequence of ingenious links, Bak makes each of the paintings in the series a gloss on the artistic content of all the others. Here the vista is open, the water calm, the craft moored in a proper harbor. The Star of David faintly imprinted on its prow marks it as another ship in the convoy that memorializes Jewish fate.

But other sinister images intrude: instead of heralding imminent departure, the twin stacks issuing dense, almost petrified smoke violate the climate of normalcy by solemnly summoning us to the memory of a people's doom. Poet Nelly Sachs has condensed this diabolic vision into a mournful threnody: "O you chimneys,/O you fingers/And Israel's body as smoke in the air," and Bak has captured with visual precision the verbal impact of these lines.

For the artist, images such as these bear a double meaning, from the perspective of creation and the perspective of loss. The sturdy brick sides of the vessel refer us to another monument of destruction, the temple Wall in Jerusalem, mute testimony to an earlier if less lethal assault on the integrity of Jewish life. On board, two blank stone tablets note the suspension of the Lord's covenant, while jumbled ruins of houses recall the disappearance of the Jewish community.

Little is as it has been or should be: the commandments have vanished from the Tablets of the Law; the wooden ship has been turned to stone; and though a friendly natural vista now invites departure, no one is left to depart. As the eye shifts back to *Alone* and forward to other paintings in the series, the mind slowly learns to adjust to a doctrine of artistic uncertainty, one of the many painful legacies of the Holocaust experience.

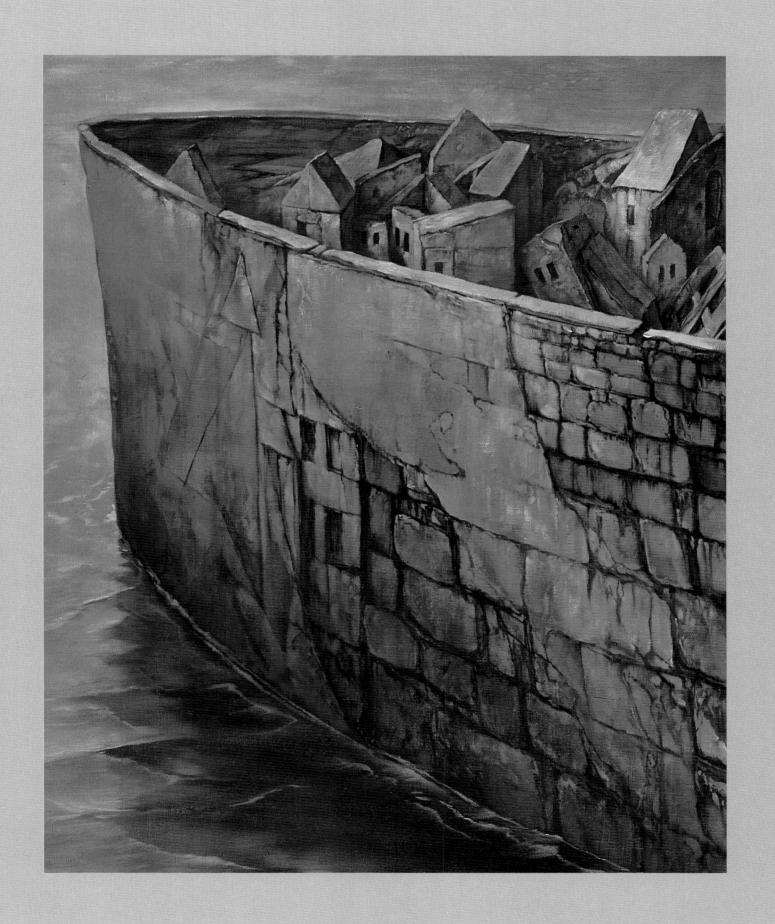

Journey
1991
200 x 160 cm
Oil on canvas

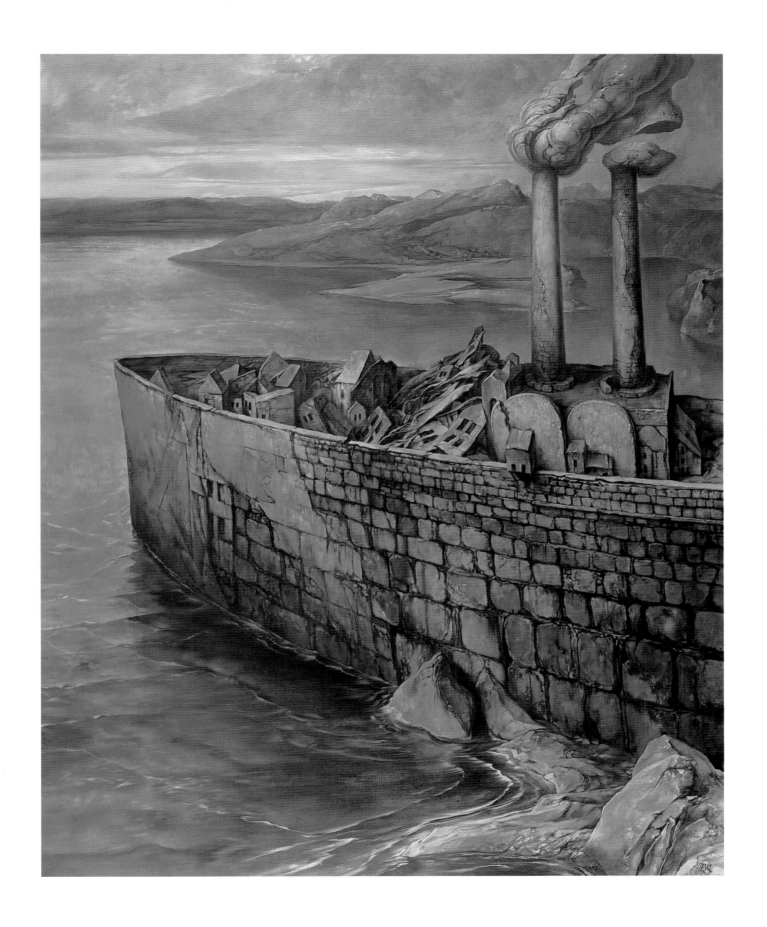

6. Home

Home is a composition in competing horizontal and vertical lines, as the eye is forced to travel in two directions at once. As smoke drifts past the painting's upper frame, massive stone blocks stretch beyond its outer edges. Like its theme, this canvas could be sub-titled "to be continued." The search for a final locale of Jewish identity is another recurrent motif in the *Landscapes of Jewish Experience*. Home is an inconclusive credential for a people known through legend and history for their wandering—to and from a native terrain, or transient place of exile, or more recently, the sites of their murder. The wish of Jews to settle down in a place called home has been disrupted by repeated efforts of others to resettle them elsewhere. The ultimate violation of this wish occurred during the Nazi era, when the German term *Umsiedlung* (change of home, resettlement) was used to describe the transports to the regions of Auschwitz and Treblinka.

Many of these ironies are implicit in the imagery of this painting. From the window of a humble dwelling in the foreground two tapers spill their domestic smoke into the air. In normal times, a viewer might comment on the parallel stacks behind the wall belching their industrial pollutants into the same atmosphere. But in the post-Holocaust era our definitions of "normal" have undergone a sea-change. Ordinary stovepipes, like the ones above the small house, seem to have lost their function, to be replaced by the gruesome chimneys of the crematoria. The wall, in other words, intervenes between normality and catastrophe, leaving us to imagine what kind of destruction was enacted behind its facade. But another Wall is evoked by this barrier, from whose stones a different temple of Jewish memory has been rebuilt. The idea of "home" is thus both tainted and reborn through the multiple visual associations of the painting's interlocked images.

Home
1992
200 x 160 cm
Oil on canvas

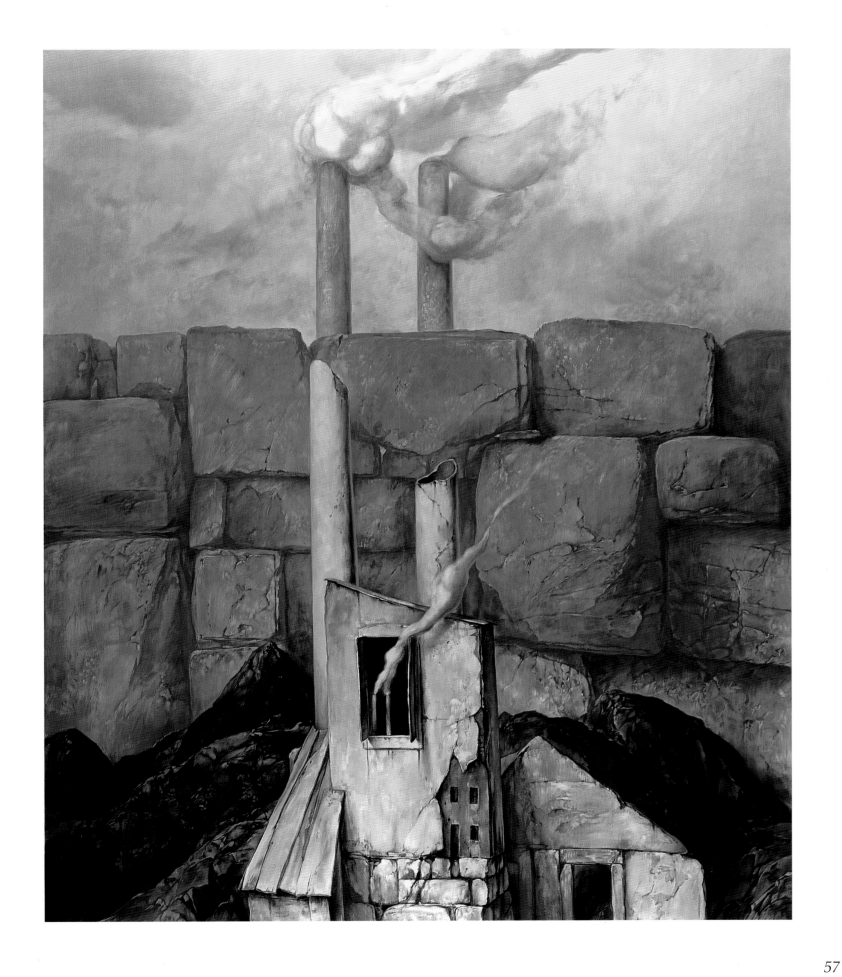

7. *Smoke*

Smoke could be viewed as a direct outgrowth of *Home*, though our perspective has changed and we are now gazing downward at the chimney, whose smoke has petrified and is expanding into a vast cemetery in the sky. Instead of dissipating, as we would expect, the smoke undergoes a dreadful metamorphosis into the unnatural solidity of a rocky terrain. During the Nazi era, the Germans reshaped Jewish destiny into a journey from

flesh and spirit through flame and smoke to an eternity whose visual dimensions have grown as grotesque to the imagination as the grisly sources of that journey. A sort of magic realism of the eye keeps this heavy mass buoyant despite its weight, just as in other paintings stone vessels manage to defy physics and stay afloat.

A lurid glow lights the surface of this misplaced graveyard, a bizarre heavenly catacomb, though any language we use to describe it is bound to seem

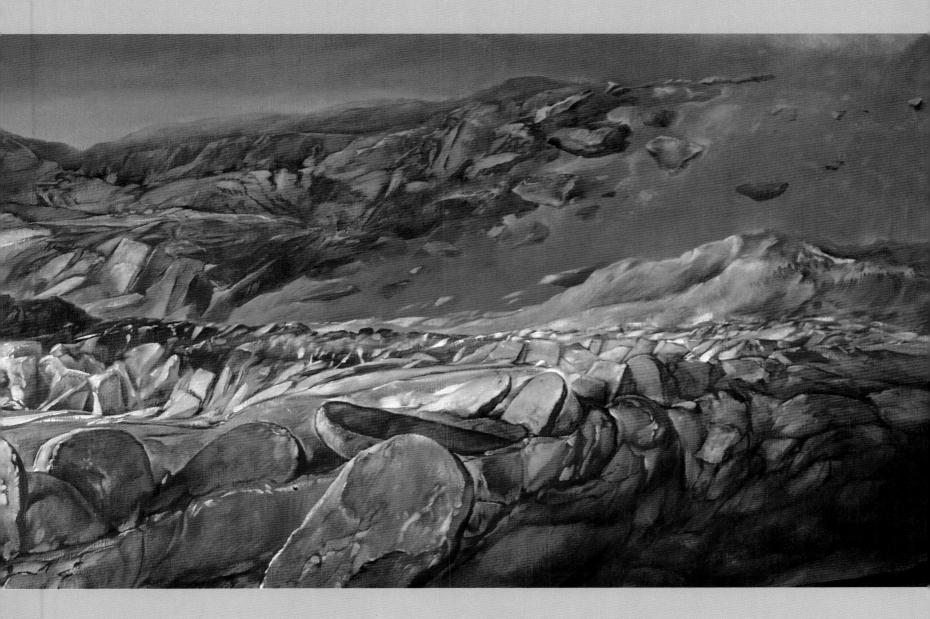

unsatisfactory. The Germans left no home on earth for the Jews when alive; neither did they leave any place on earth for mourning them dead. If a divine welcome awaits them, there is no sign of it here. *Smoke* is a haunting memorial to a lost community adrift in space, not as a consolation to give meaning to its members' lives, but to raise the issue of an appropriate form to commemorate the loss and to question whether any ever can be found.

Smoke
1990
200 x 160 cm
Oil on canvas

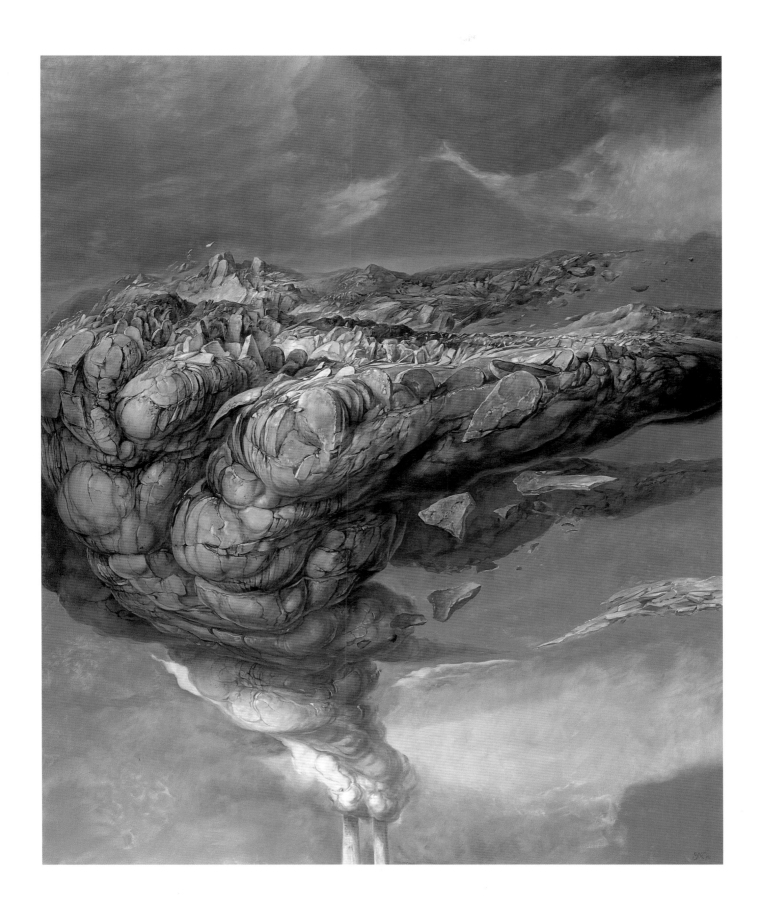

Both *Smoke* and *Flight* invoke episodes from the Jewish past and the Jewish present. Smoke turned to stone reminds us that God came to Moses on Sinai in a thick cloud of smoke, in order to give him the stone Tablets of the Law, while *Flight* portrays another kind of Exodus, though the modern destination can hardly be called a Promised Land. Unlike the petrified density of *Smoke*, the weightless mass of *Flight*, unanchored from its origins, wafts upward without apparent purpose. Flimsy house

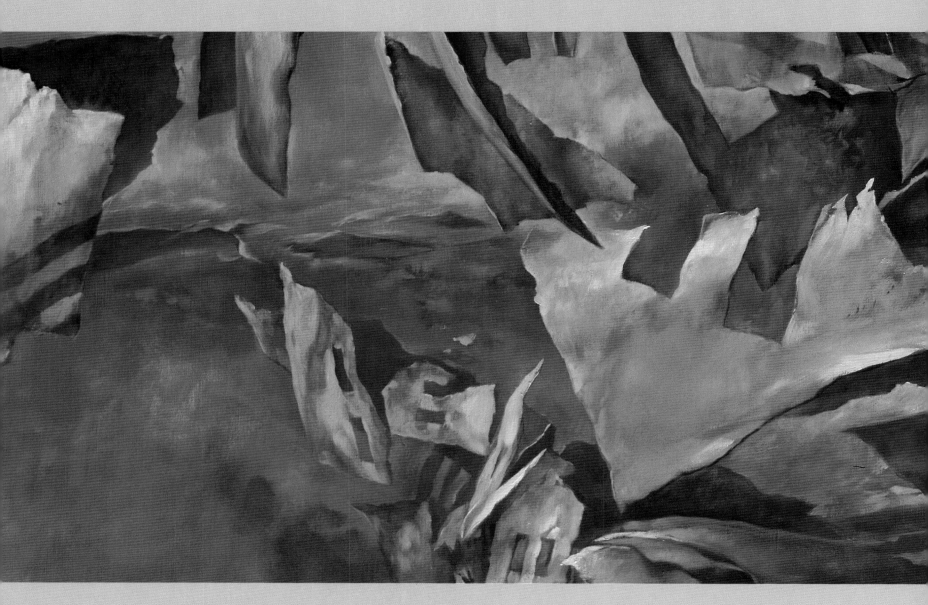

facades and remnants of prayer shawls and striped uniforms of concentration camp inmates cluster together like scraps of paper blown about by a hot wind, creating an occult diaspora of Jewish memory in the sky.

Rising from these buoyant emblems of a community in ruins are the majestic Hebrew letters for Shema [שמע], "Hear," though whether this signifies a plea for help or a renewed hymn of praise to the Lord, we are left to decide

for ourselves. The language of ritual prayer, given the bewildering images before our eyes, is unavoidably tinged with ironic overtones. The entire scene seems bathed in a fiery light, though whether this implies divine presence or the fury of the Final Solution we have no way of knowing. We are forced to absorb both possibilities.

The name of God is clearly acknowledged by the adjacent yods [״] at the top center of the painting, but there is no further sign of covenant, broken

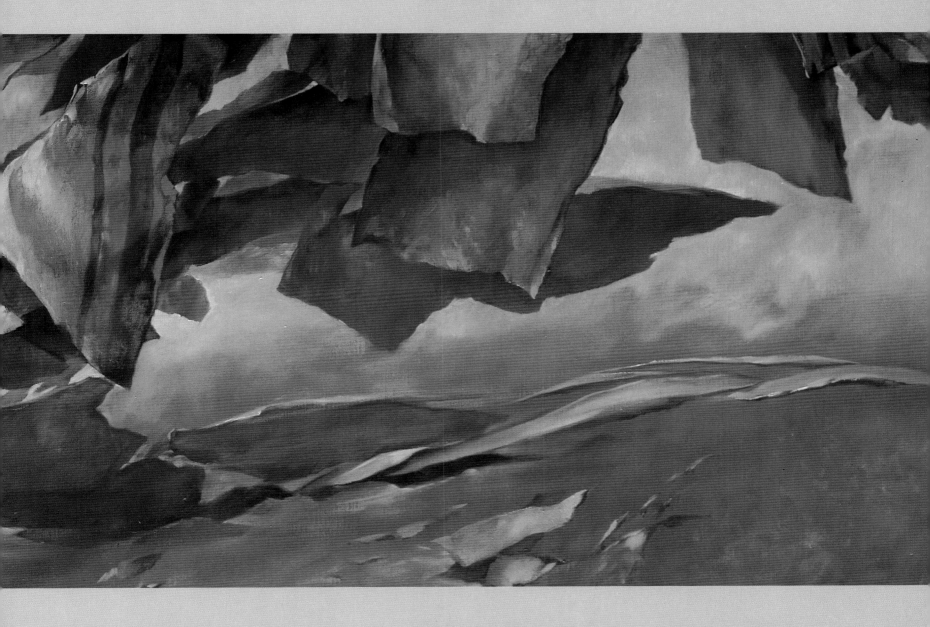

or renewed. Like the surviving Jews in the post-Holocaust period who were uncertain whether to return to an old home or migrate to a new one, the unmoored relics of reality in *Flight* glide toward an unpredictable goal—or perhaps no goal at all.

Flight
1991-1992
200 x 160 cm
Oil on canvas

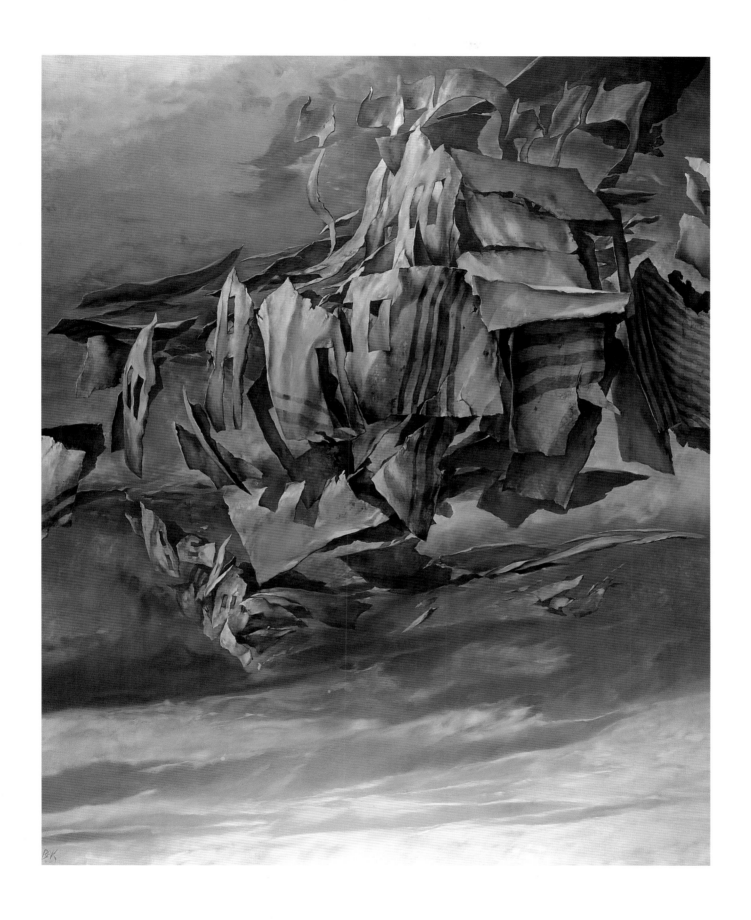

The diptych *Hidden Question* appears almost midway through the series *Landscapes of Jewish Experience*, dramatizing in pictorial form the central philosophical and religious issue that joins Holocaust to Jewish history: where was God? The role of God in creation is clear from scripture, but the absence of divine power and love from the catastrophe remains a dilemma.

Reading from right to left as Hebrew requires, the first half of the panel shows a stone arch, perhaps the remnant of a petrified rainbow, crushing the tower of what may have been a temple of the Lord. Backed by an ominous cloud, the shaft of a broken key is tipped by two Hebrew letters, from which two *yods* shine forth--the holy name of Adonai, the Lord. But the other end of the key has broken off and lies rusting on the arch, its handle in the shape of a question mark. Dark shadows and radiant light combine to introduce a metaphysics of indecision, creating a display of alternatives that resists closure, to say nothing of final meaning. A visual text such as this provokes the viewer to enter into the challenge of interpretation with all fixed expectations or prior beliefs temporarily suspended.

In mood, coloration, and density of form, the left panel is the opposite of its companion. The heavy stone arch has exploded

into fragments, releasing the temple tower from its oppressive burden. The tower now emerges undamaged against a brighter sky. Jewish life on earth may regroup, though the key to the mystery of God's presence in the universe during the Holocaust remains part of the painting's shattered imagery. The handle of the key is now a zero, the nullity of emptiness, though it also takes the shape of the Hebrew "s," first letter of *sod*, the word for "secret." The *yod*s for God's name reappear, the broken tops of the letter shin [ש], as if to remind us of the need to rewrite the Jewish narrative by adding destruction to the original story of creation. The alphabet to tell that story is itself no longer intact, though not beyond repair.

The entire tone of the left panel of the diptych is less severe than the right one, leaving suspended the essential identity of the divine nature. The broken keys to the enigma of deity are visible, though the keyholes inviting us to enter the realm of God's intentions are nowhere to be seen. New definitions are needed to account for the ravages of mass murder. Earlier, the language and vision of European Jewry had been unprepared for what lay ahead; now, both language and vision prove inadequate for what lies behind.

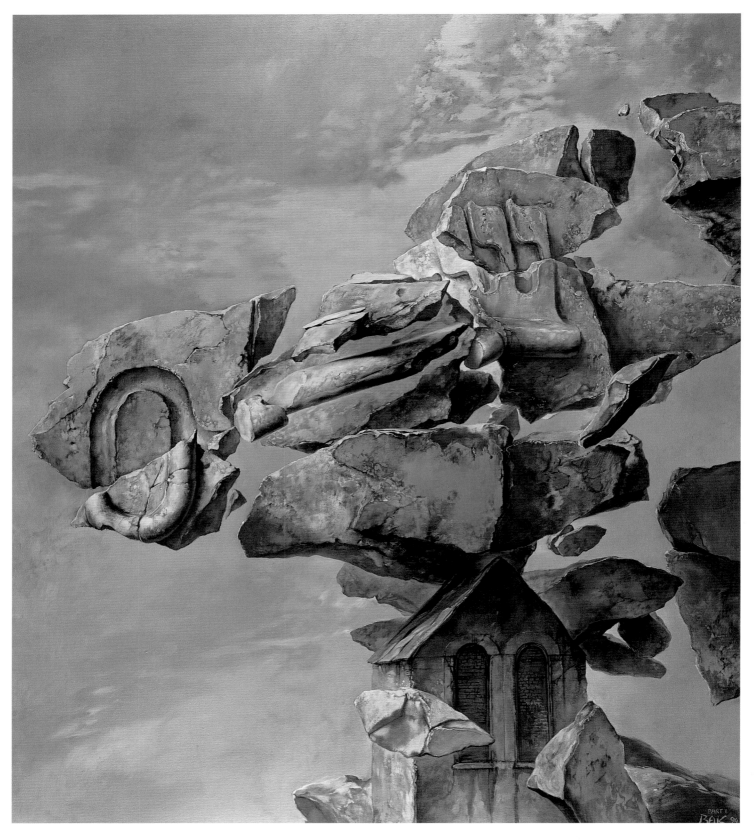

The Hidden Question
(part I) 1994 160 x 140 cm Oil on canvas

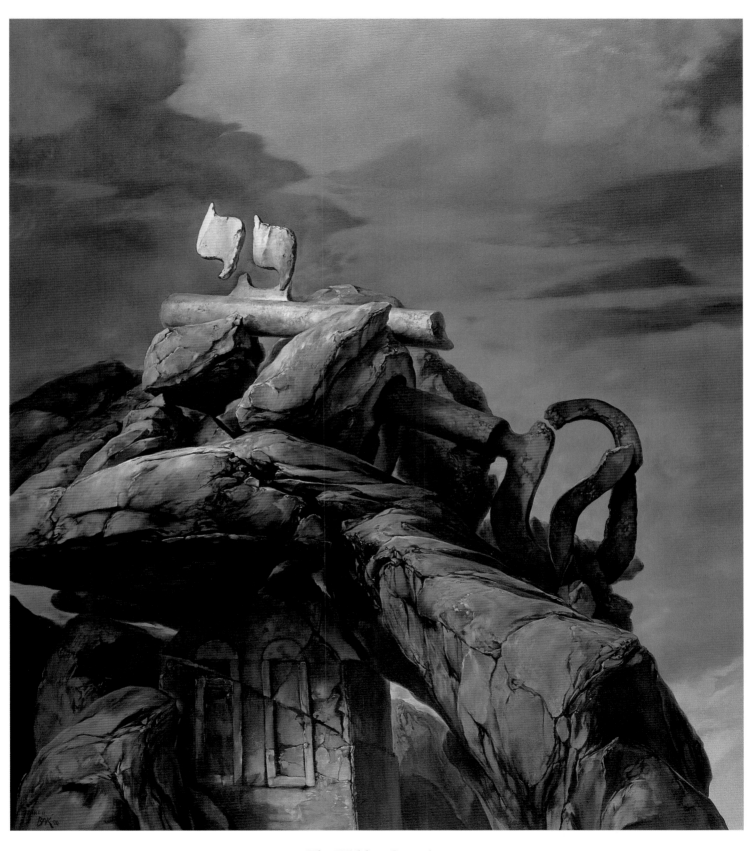

The Hidden Question
(part II) 1994 160 x 140 cm Oil on canvas

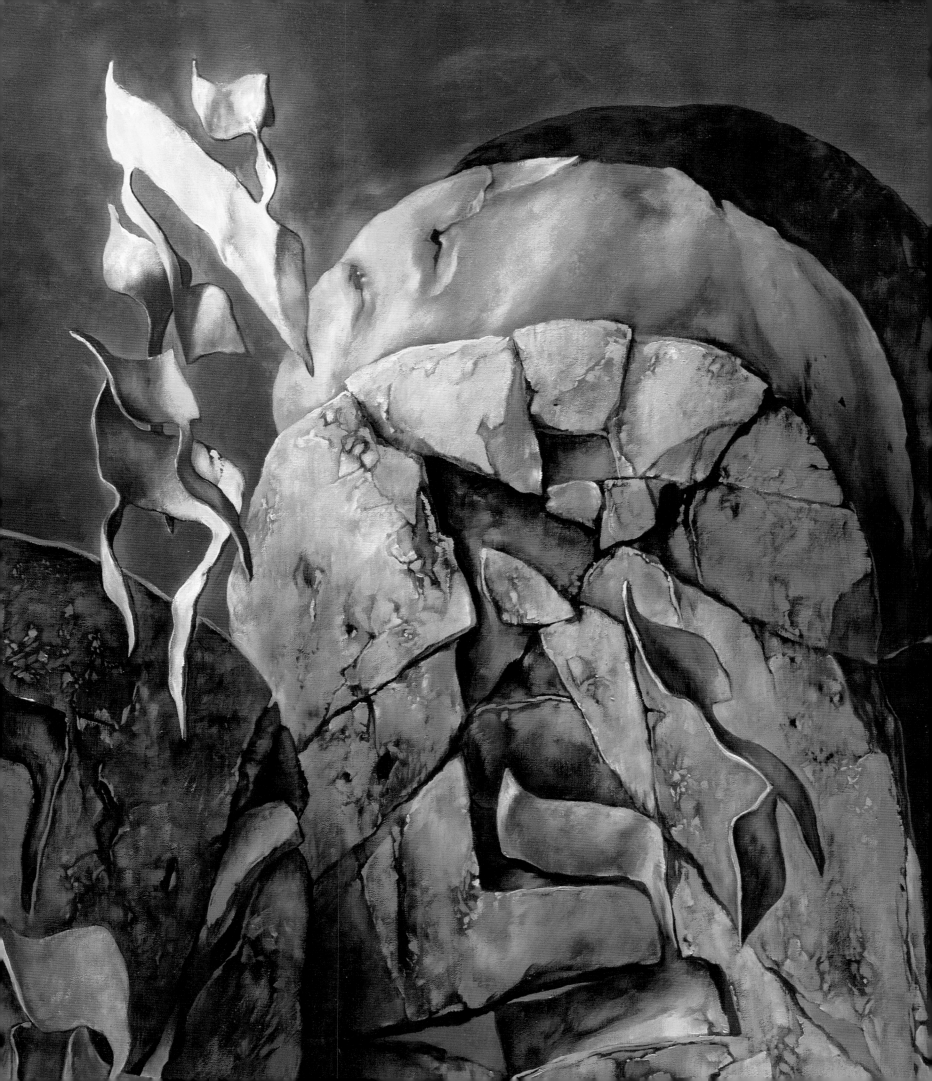

10. Othyoth ["Letters"]

The Tablets of the Law, a crucial image in this series, now emerge in regal but crumbling splendor. The executioners of the Holocaust have violated one of its central tenets: "Thou shalt not murder." In that universe of destruction, the Ten Commandments have lost their coherence. Its letters fly from their mooring, floating freely above the barren terrain below. A golden aleph, glowing with celestial radiance, crowns the painting, but nothing is truly whole. The letters are detached from their original sequence, while the solitary aleph reminds us that half of the divine name, "El" [אל], is missing.

The source of the discordant visual force of these disintegrating ethical imperatives is implicit in the language of Exodus itself, which with uncanny portent forecasts through its imagery the unforeseen fate of the Jewish people at the hands of the Germans:

> "Now Mount Sinai smoked all over,
> since YHWH had come down upon it in fire;
> its smoke went up like the smoke of a furnace,
> and all of the mountain trembled exceedingly.

[Exodus 19:18]

Bak refuses to discard the tradition of law that has sustained the Jewish people throughout its many ordeals; but he knows that the unholy fires of Auschwitz and the other deathcamps have consumed more than the bodies of their victims. An entire structure of belief must be scrutinized anew, as if the stable iconography that once held a community together had to be redesigned to include the volatile shock of mass murder.

Othyoth
1992
200 x 160 cm
Oil on canvas

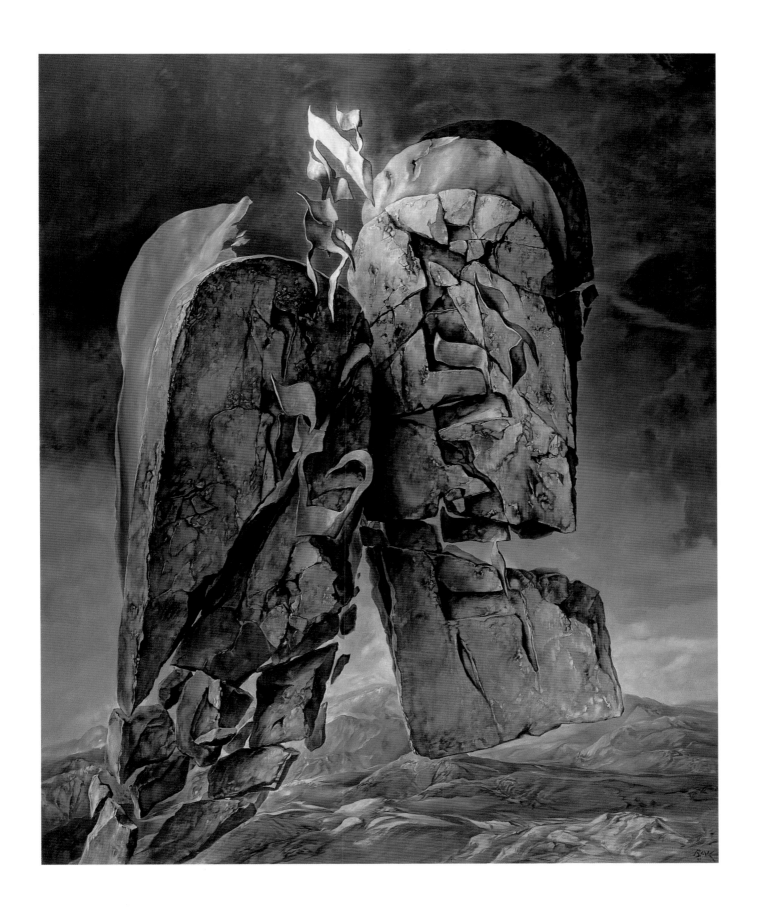

Amidst this world of stone we find explicit reminders of the tension between the covenant for spiritual survival on Sinai and the German ideology of death that led to the extermination of so many Jewish communities in Europe. Looming from the wreckage of the Tablets of the Law strewn across the mountain's slope is a fragment on which a part of a giant "6" is engraved. "Thou shalt not murder" was the sixth commandment; but in the arithmetic of Holocaust memory, that number bears a far more fatal meaning.

At the base of the peak we discern the Hebrew letters of "Shema Yisrael"; while from its summit rise two stone tablets, blank except for the now familiar twin yods [יי], the name of the Lord. These markers are set against a clear and placid—some might argue "empty"—sky. At their feet lies a smaller tablet, reminder of an earlier dispensation, bearing the aleph and bet of the first commandments about proper worship of the God of Israel. But these tokens of an ancient faith, both the prayer and the commandments, suffer

diminished force by the advent of mass murder. How shall the cry of "Shema Yisrael" be heard in this cold and barren atmosphere, lacking human presence or divine? Can memories besieged by catastrophe ignite the spark for a renewed covenant?

Nothing glows golden here—only an arid terrain, shadowed by a blue and purplish hue. There is no sign of the thick cloud of smoke that greeted Moses on his ascent to Sinai. Yet the fusion of language and image that animates so many of these paintings with a kind of visualized literary text invites hope for a new inscription, through the consciousness induced by art, of the meaning of Jewish survival in a post-Holocaust era. The name of God on the otherwise vacant tablets may be a mockery...or a warning...or a challenge. *Shema Yisrael* summons the viewer to an active role in re-visioning—and then revising—both past and future versions of the narrative of Jewish destiny.

Shema Yisrael
1991
200 x 160 cm
Oil on canvas

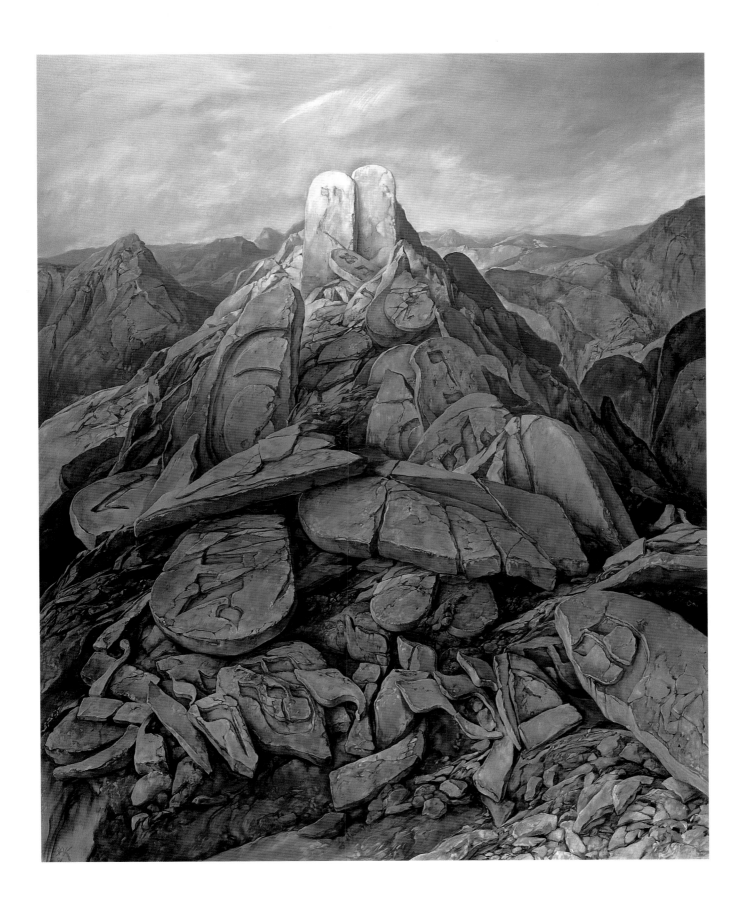

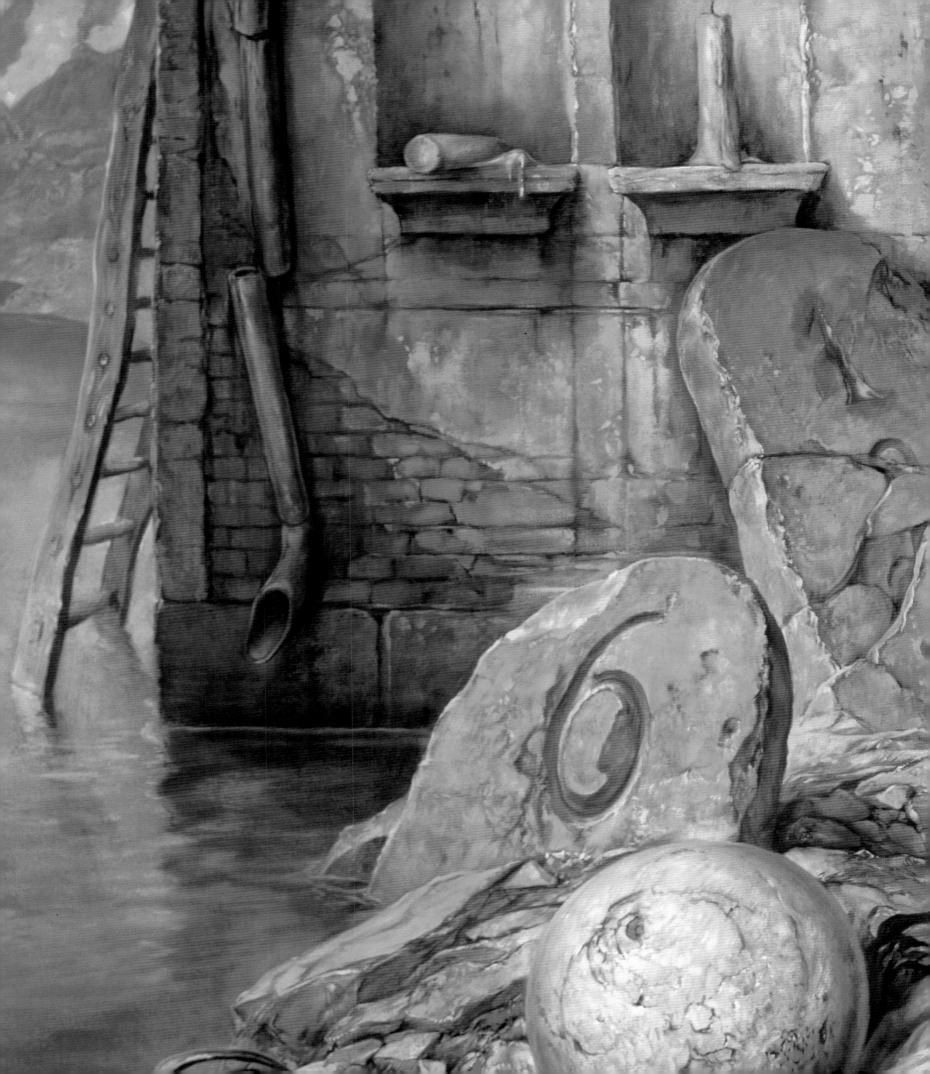

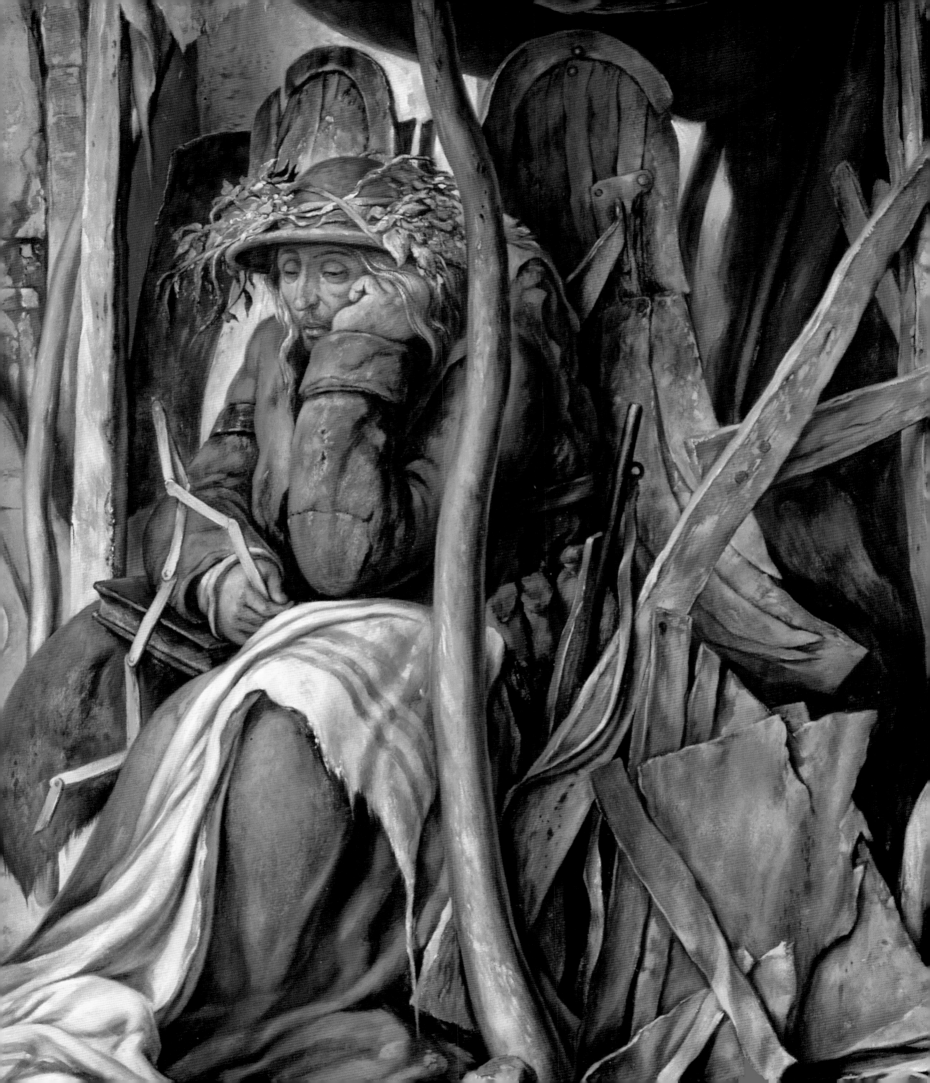

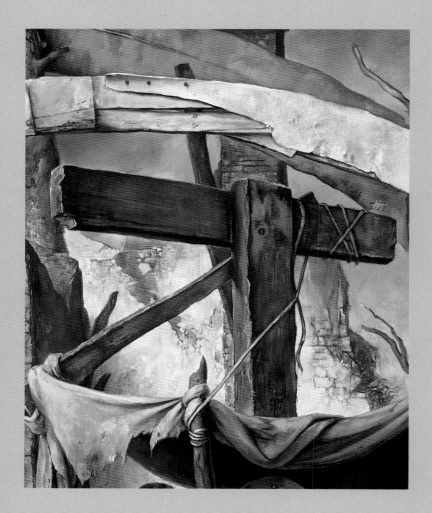

Nothing is plainer in the *Landscapes of Jewish Experience* than how the Holocaust has altered our perception of familiar words and images. Once merely the name of a well-known city in Germany, "Nuremberg" today has lost its pristine innocence. The mammoth Nazi rallies there during the Hitler era and the war crimes trials following the Allied victory have created a totally new context for hearing the term: it is now associated with a criminal regime, and the atrocities it committed. Our vocabulary has been contaminated, leaving an indelible stain.

The same is true for our images of spiritual reality. This is a major theme of Bak's *Nuremberg Elegie*, which mimics the setting and details of Dürer's famous engraving of the early sixteenth century, *Melencolia I*. The brooding winged figure in Dürer's work has been variously interpreted to represent artistic genius despairing of inspiration, or more generally a summing up of the medieval and Renaissance mind's response to the mysterious sadness of the world. Bak substitutes a helmeted soldier whose heavy-lidded eyes stare downward, masking any inner anguish he may feel. His helmet is wreathed with some camouflaging greenery that replaces a more traditional crown of thorns. Above him, backed by a partly concealed brick chimney, rises a crucifix whose top has been lopped off, leaving the shape of a wooden gallows. One source of melancholy for the twentieth century imagination is the utter failure of Christianity to curb the catastrophe of European Jewry.

Unlike Dürer's engraving, which is crowded with allegorical items demanding illumination, Bak's images are easier to decipher. Across the seated

figure's knees lies a Hebrew prayer shawl; at his feet are strewn the brightly-colored tattered remnants of some rainbow-colored cloth that must have been stretched across the arch rising above his head. Certain promises to the children of Israel have not been fulfilled. As if to verify this, on the soldier's other side lean the familiar Tablets of the Law, the number "6" prominently carved onto one of them. In the empty spaces of a chapel face where they once stood burn two memorial candles, one upright, the other prone. The wisps of smoke from their thin flames are etched into the brick, as the fleeting physical fate of the Jews is once more converted into the inert permanence of stone. In the distance, two parallel larger plumes of smoke drift upward, tinting (and tainting?) an otherwise placid sky.

As the landscape assimilates mementoes of destruction, the viewer is charged with the task of asking how human vision, and the artist in particular, can sculpt form and beauty out of such chaos. That was the challenge to God at the original moment of creation. But chaos now includes the near annihilation of the Jewish people, as the *vov* and *gimel* (for the Vilna Ghetto) alongside a Star of David in the painting's foreground vividly remind us. Unlike the boy in *Self Portrait* who grasps in his hand a paintbrush, the implement of his future craft, the brooding figure in *Nuremberg Elegie* holds an awkwardly unfolded carpenter's rule, as if searching for a way to measure the difficult test before him. Here and in Dürer, the ruins of time threaten to overwhelm the artistic will, though the inhumanity of the Holocaust shadows our dream of a human future with a potency unknown to Bak's Renaissance predecessor.

Nuremberg Elegie
1994-1995
200 x 160 cm
Oil on canvas

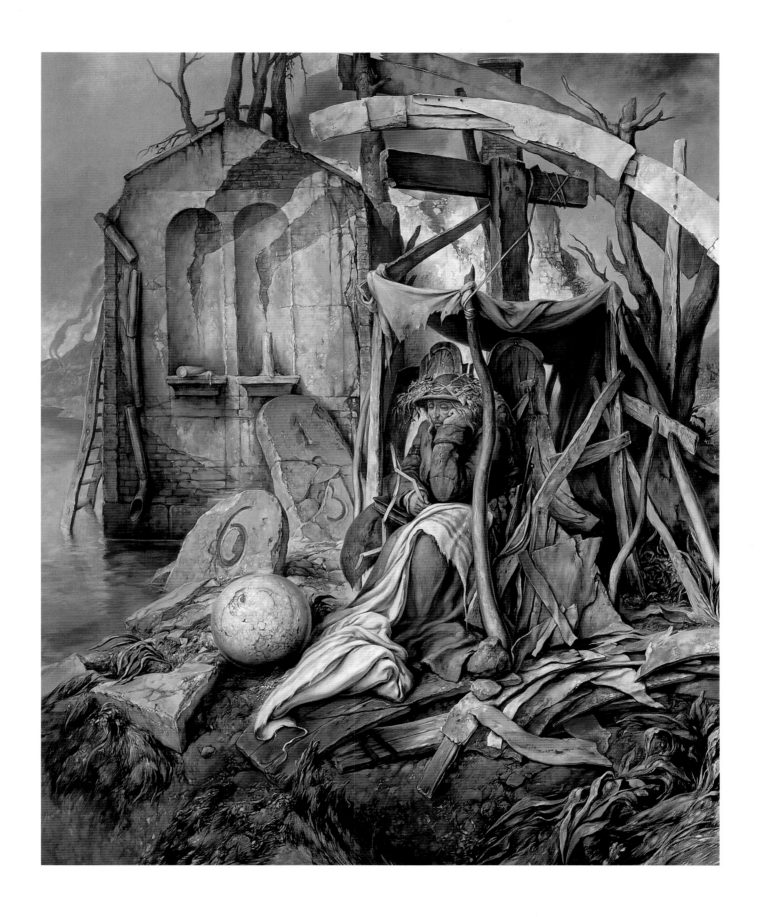

13. *From Aleph to X*

Unlike the glowing enigma of *Othyoth* or the richly differentiated details of *Nuremberg Elegie*, From *Aleph to X* offers us a nearly monochromatic canvas, on which the objects—chiefly the looming Tablets of the Law that seem to erupt from the surface of the earth—merge with the pallid pinkish hue of the surrounding landscape. Only a trace of yellow on the prone Star of David at their base adds a touch of color to a scene that otherwise appears to have been drained of all spiritual pigment. The smoke from a chimney is imprinted on the tablets, then drifts past them to melt into the sky, as if an indifferent nature could easily absorb the litter of atrocity without being tarnished by the process.

Hebrew letters and Roman numerals identify the Ten Commandments, raising the question of how to find a fresh language of moral authority to govern Jewish life in the post-Holocaust era. If a renewed covenant is possible, how is it to be written, and how is it to be seen? In From *Aleph to X*, the first cipher of the Roman number VI for the sixth commandment combines with the extruded "G" or *gimel* [ג] on the right hand tablet to give us once again cues for the Vilna Ghetto, whose remains seem sheltered in the spaces of the fallen Star. For Bak, there is no entry into a reborn future without passing through the deathscape of the Holocaust. We rehearse the risks of the journey in the very exercise of viewing the *Landscapes of Jewish Experience*.

From Aleph to X
1991-1992
200 x 160 cm
Oil on canvas

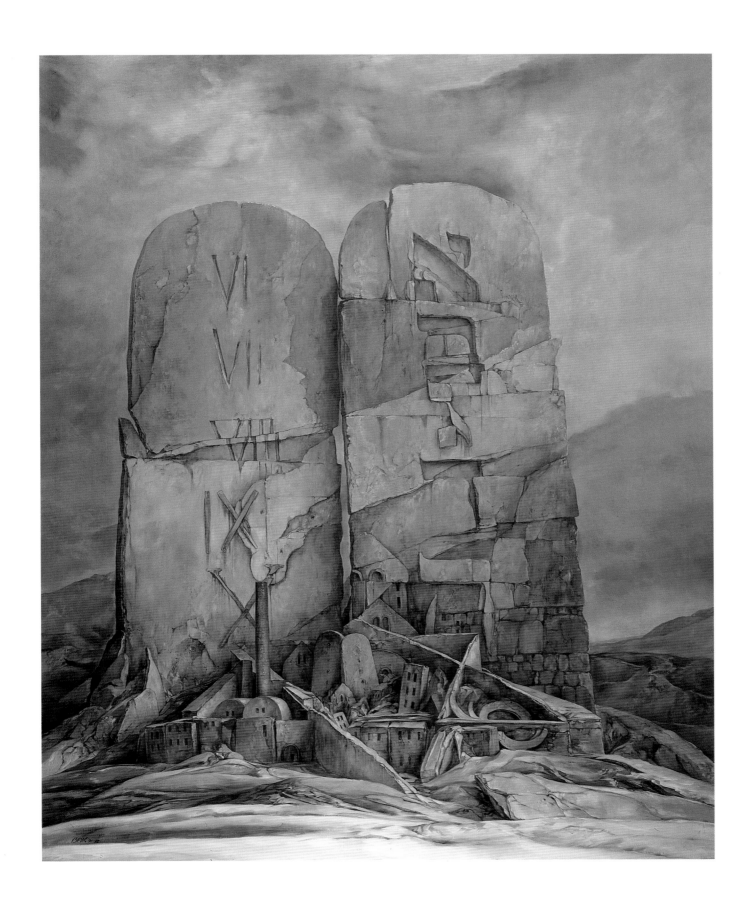

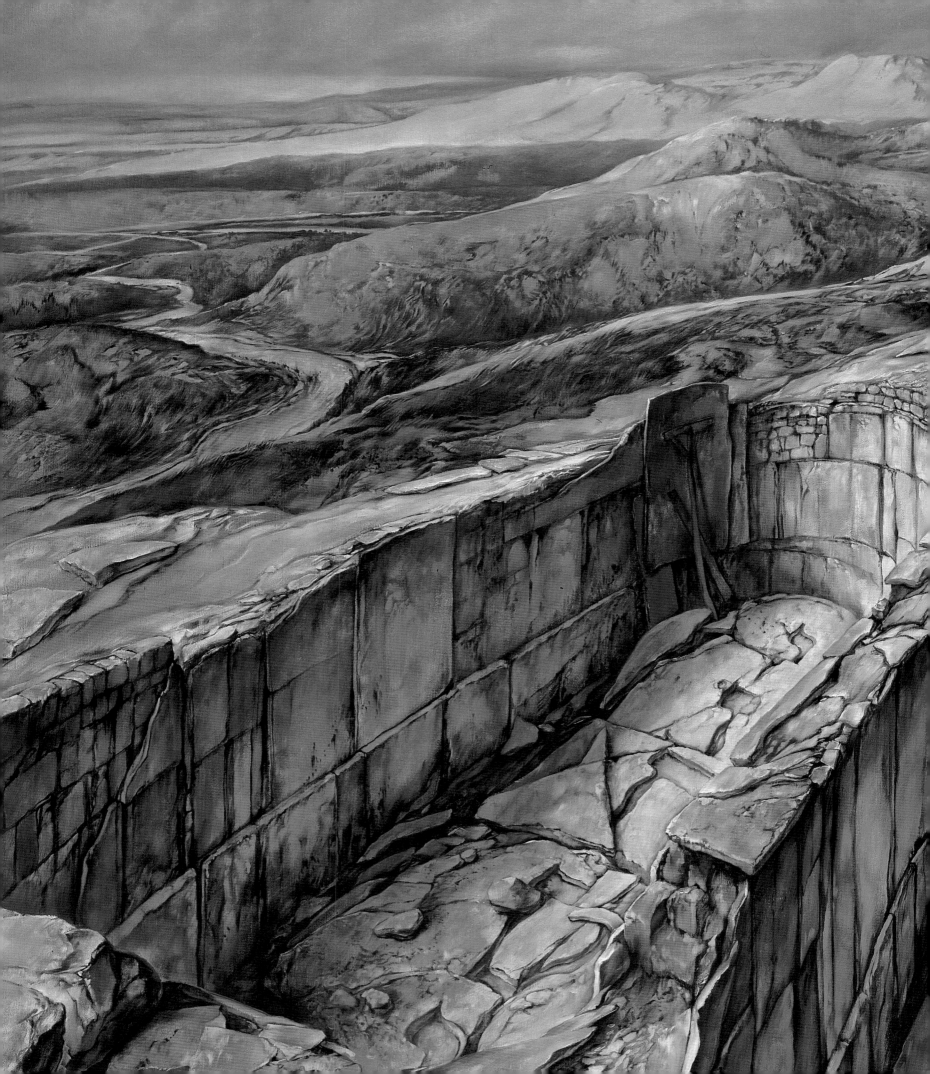

14. De Profundis

De Profundis might have been sub-titled "Sinai Elegie," an "In Memoriam" to the once vital tradition granted to the children of Israel during their wanderings in the desert toward a Promised Land. Psalm 130 begins "Out of the depths [De profundis] I call you, O Lord," and for those victimized by the Holocaust, this plea must have had a special appeal, along with other lines from the same Psalm: "O Israel, wait for the Lord: for the Lord is steadfast love and great power to redeem." For some viewers, history will have crippled this sentiment with the fatal blows of annihilation. For others, the intact Star of David at the head of the crypt may signal reliance on a surviving culture.

"Seeing," here as elsewhere, demands more than a visual response. The stark landscape before our eyes, a modern Negev as well as an ancient desert, displays the tombs of the Ten Commandments, whose fragments lie buried in adjacent graves, though no one (but us) is present to mourn their demise. Are we to conclude that not only stone fragments lie buried in these graves? Can the moral force of these ruined tablets be repaired, strengthened, rise, as it were, from the depths to denote a renewed if more tentative bond between God and His people? Or has the diaspora of ashes scattered across an absent landscape by the triumphant enemies of Israel in Europe cast a blunt irony over the setting of *De Profundis*, dashing the Psalmist's hopes? Psalm 130 itself is plainly headed "A Song of Ascents." But the panorama of *De Profundis* is not vertical. Its furthest vistas lead outward toward a distant horizon, not upward toward the heavens. There is, however, one possible exception to this limited perspective. In the left foreground a piece of ladder projects onto the scene, a device for descending or climbing, depending on how we choose to use it. A road winds through this lonesome terrain, and we are left wondering what mission its travelers might have—should any ever appear to undertake the challenging task of nurturing its arid surroundings.

De Profundis
1992
200 x 160 cm
Oil on canvas

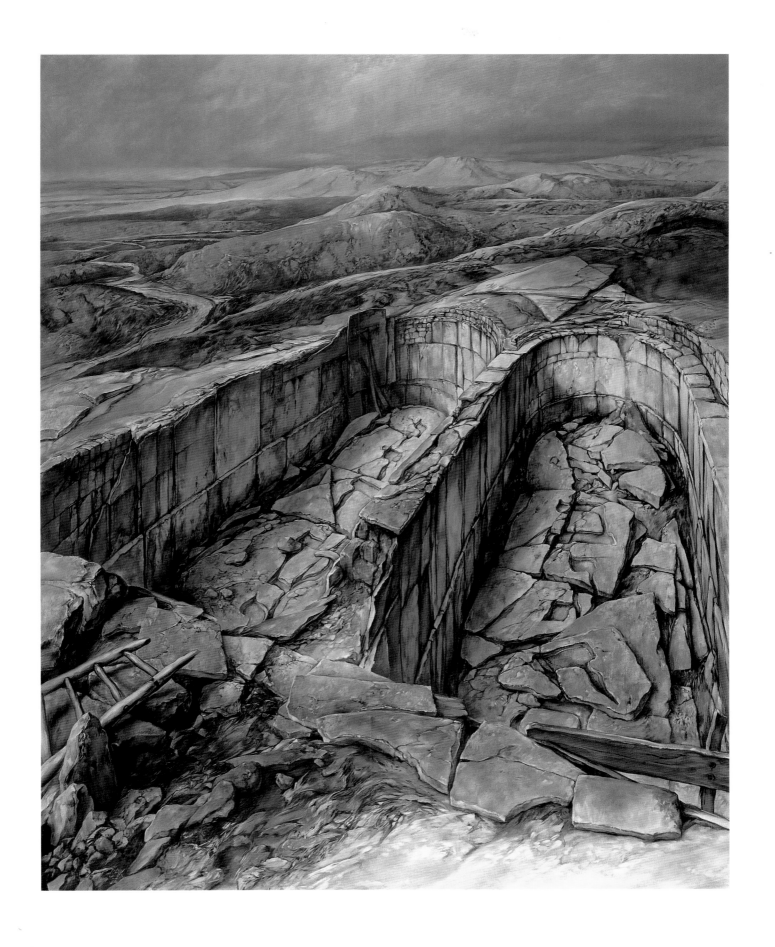

15. Family Tree

Severed from its trunk, the upright tree in this painting seems suspended on air, a surrealistic violation of the laws of nature, while the greenery in the background offers us one of the few thriving landscapes in this series. Among the many paradoxes of the Holocaust is the way in which nature—both physical and human—continued to flourish even in the midst of atrocity. That some members of the Jewish community survived in spite of efforts to uproot them all remains for many a tribute to the vitality of a beleaguered people. So the spectacle of a living dead tree is founded on historical fact, a phenomenon familiar to anyone who after the war wondered at the return of family members everyone had long since thought dead. If nature abides with the unnatural here, that is only a reflection of the ordeal of European Jewry during its darkest hour.

What is left to be resurrected from this wreckage? *Family Tree* abounds in ironies, not the least of which is the cruciform branches hidden amidst the leaves. The leaves themselves, shaped like Stars of David, drape from the branches with fading splendor, an autumnal glow before they fall. Some are pierced by twigs, reminding us that these star-leaves once marked their wearers as candidates for death. They commemorate a past; we cannot mistake them for the rich greenery of spring.

Yet the imagery of *Family Tree* is not just a souvenir of loss. From the intact stump, still firmly implanted in the earth, a single shoot brandishes its own leaves, unfurling the promise of renewed vigor in the coming year. It is a tiny token of hope, but given the vastness of the catastrophe, one would have to be quixotic to expect more.

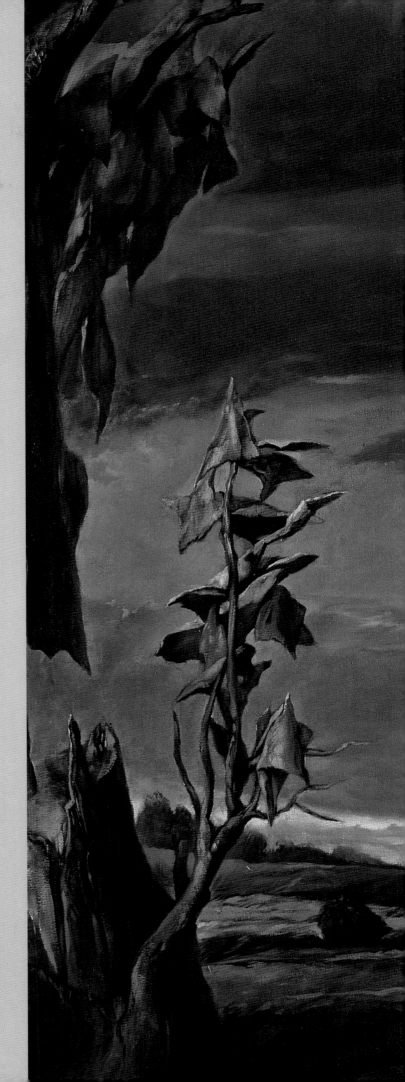

Family Tree
1995-1996
200 x 160 cm
Oil on canvas

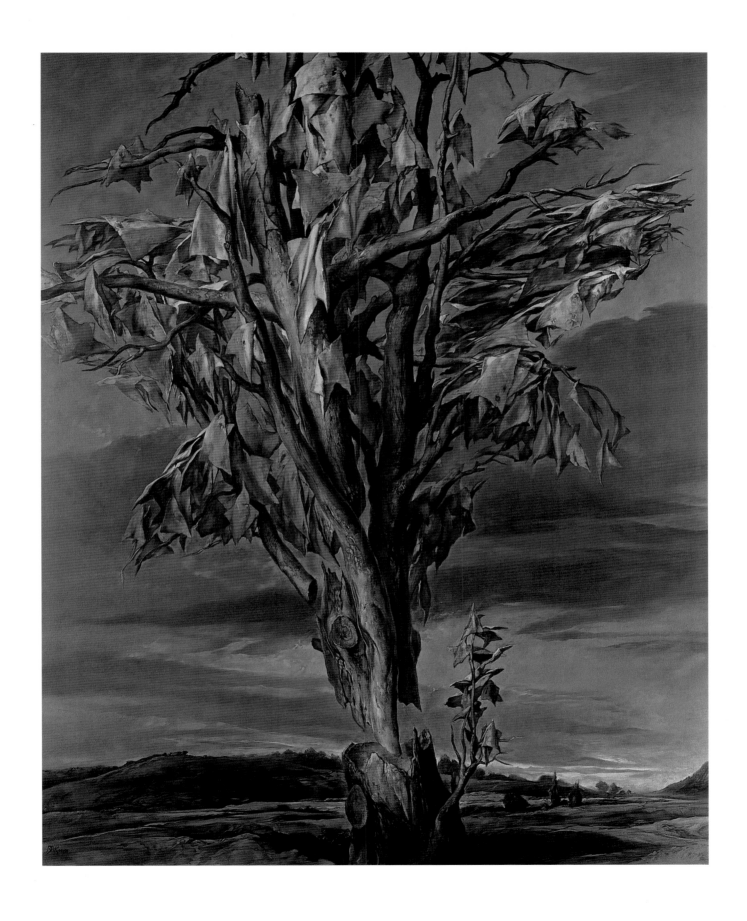

16. Destinies

The tree in *Destinies*, supported by crude crutches, is a more wretched remnant than its predecessor in *Family Tree*. Also resembling Stars of David, its leaves have begun their mutation into another substance, a process common to many of the paintings in this series. Some of them have taken on a metallic sheen, echoing the literal meaning of Magen David—shield or defender of David. This is a wounded tree, maimed by an unequal conflict whose source alert viewers should be well aware of. The remains of a brick wall suffice to remind us of the nature of that violent encounter.

The trunk has been sheared from its base, but the stump itself has also been ripped from its native moorings. Torn from the womb of nature, its roots reach out like tiny claws in search of a more fertile earth to grasp as its home. A strange portable structure occupies the foreground of the painting, ready

to roll somewhere, but with no one to convey it, and nowhere to convey it to. As in *Family Tree*, a single thin limb sprouts from the stump, its leaves, too, mirroring a slim hope for a transplanted future.

A pink shimmer lights the clouds that frame the scene, though one is never sure, here as elsewhere, whether the origin of light is a radiant sun above or sinister flames from below. The green hills, golden leaves, and rich blue sky of *Family Tree* create a far more vivid visual impression. Both tree images prompt us to recall the twin sagas of the Jewish people, their beginning in the tale of creation and their near doom in the story of Holocaust destruction. We know the "whences," but as the pluralized title of *Destinies* implies, the mystery of the "whithers" remains to be solved.

Destinies
1995-1996
200 x 160 cm
Oil on canvas

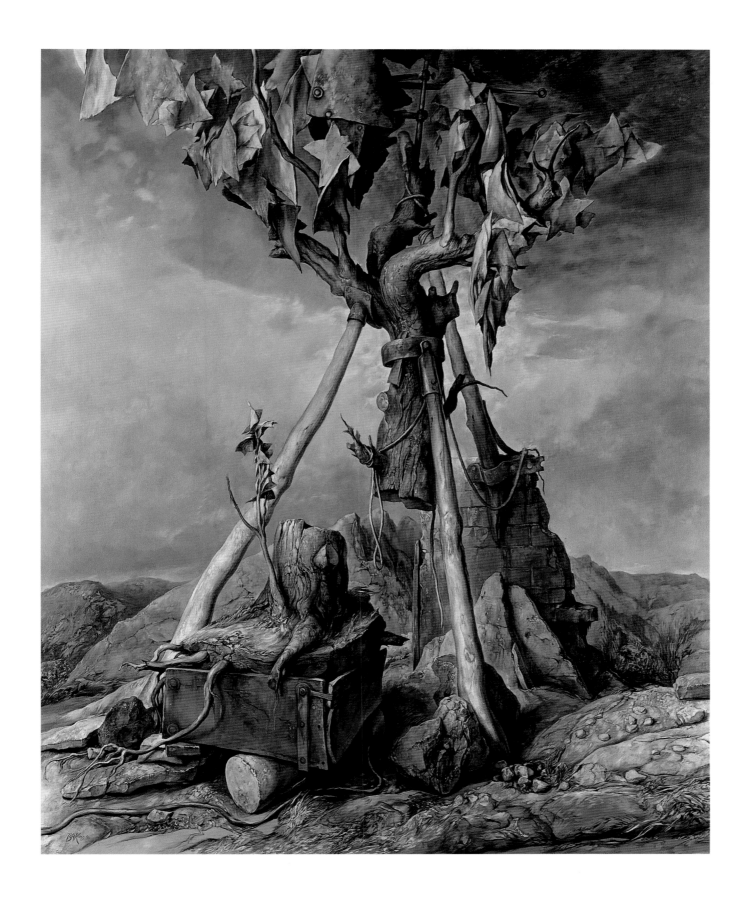

17. Pardes

Pardes introduces visual emblems of creation and destruction into a single painting, confronting the viewer with a complex vision linking them to each other. Adjacent tombs, both contoured like tablets as in *De Profundis*, are themselves divided—giving us four compartments in all. Each is fronted by a door, though access grows more difficult as we move from right to left. Above each door is a letter; together they spell "pardes, [פרדם]" the Hebrew word for "orchard" and cognate of our own word "paradise." (The word paradise is itself linked to the Greek term for "enclosure," while further etymological inquiry leads to connections with "journey" or "passing through.") All of these meanings are relevant to the challenge of Bak's vision in *Pardes*.

The four letters "p" [פ], "r" [ר], "d" [ד], and "s" [ם] refer to a fourfold system that emerged during

 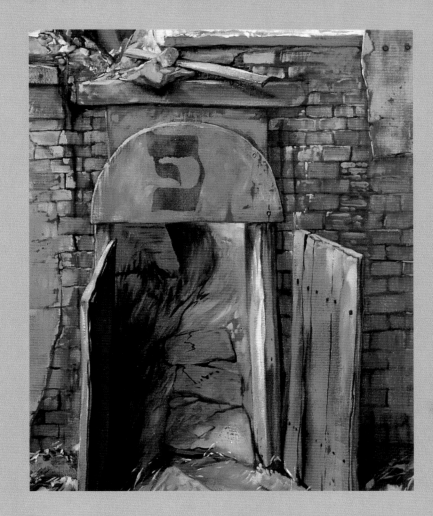

the medieval period for interpreting certain written texts. It was used not only for scriptural exegesis, but was applied by many commentators to literary masterpieces as well, including Dante's Divine Comedy. The four approaches embrace literal, allegorical, theological, and mystical readings, a strenuous voyage of the mind and imagination that carries one from the tactile core of physical reality to the evanescent mysteries of spiritual truth.

In *Pardes*, the viewer is invited to explore the passageways and labyrinthine corridors of the allegorical and theological quest that leads from the tree of life (or is it death?) on the right to the glowing furnace of death (or is it rebirth?) on the right. Nothing stands alone: the tree surges upward, as does the chimney barely visible behind the smoke (though the smoke, curiously, rises from other

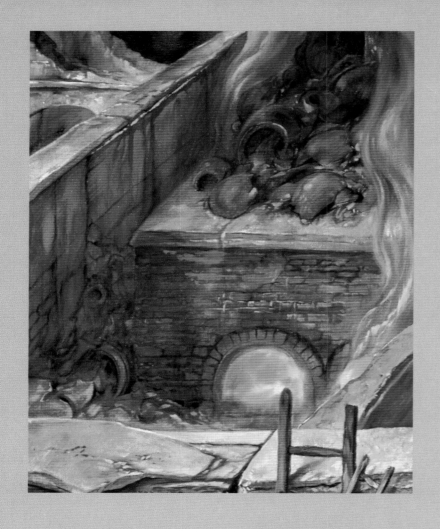

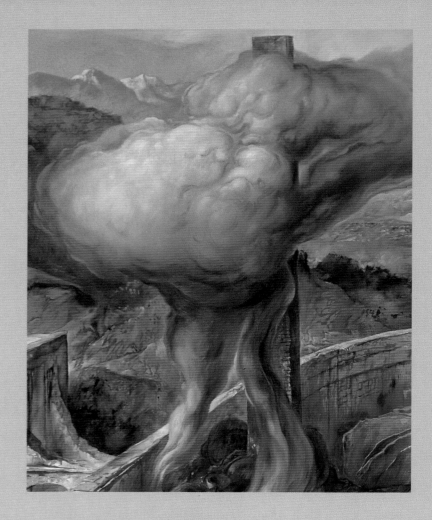

sources). But this vertical momentum is visually counterbalanced by the more insistent perspective that carries the eye toward the horizon—eastward of Eden, one is tempted to say, where the human adventure began.

Instead of apples, numbers from one to ten are draped on the tree's branches, reminders of that moment in the desert that confirmed the moral and spiritual structure of future Jewish existence: divine commitment to the human, and human commitment to the divine. What effect did the rupture of the Holocaust have on this reciprocal pact? Can any systematic analysis such as "pardes" ever explain how or why the indwelling spirit of God in the sacred fire was transformed into the destructive flames of the deathcamp crematoria? How did the travel and travail of the

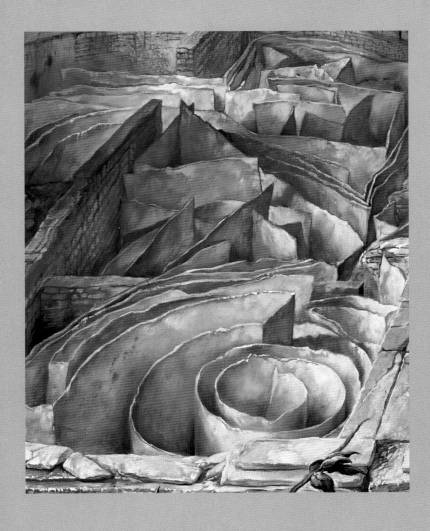

Jewish people, that began in Eden and continued in Exodus, end up in Auschwitz? In our search for answers, are traditional forms of explanation like "pardes" useful—or useless? The door to the last quadrant in this painting, the "s" for *sod* or secret, is sealed by two wooden crossbars shaped like an "X". The dilemma within, Bak's own "glowing enigma," does not easily divulge its secret—if it has one. Instead, it spews forth its own flame and smoke, that drifts upward and reaches out to embrace—and purify, or contaminate?—the tree in the area signifying literal meaning. Without providing solutions, the intricate visual text of *Pardes* helps us to define the problematic issues that face anyone seeking to wrest sense and continuity from the scourge of the Holocaust experience.

Pardes
1995
160 x 200 cm
Oil on canvas

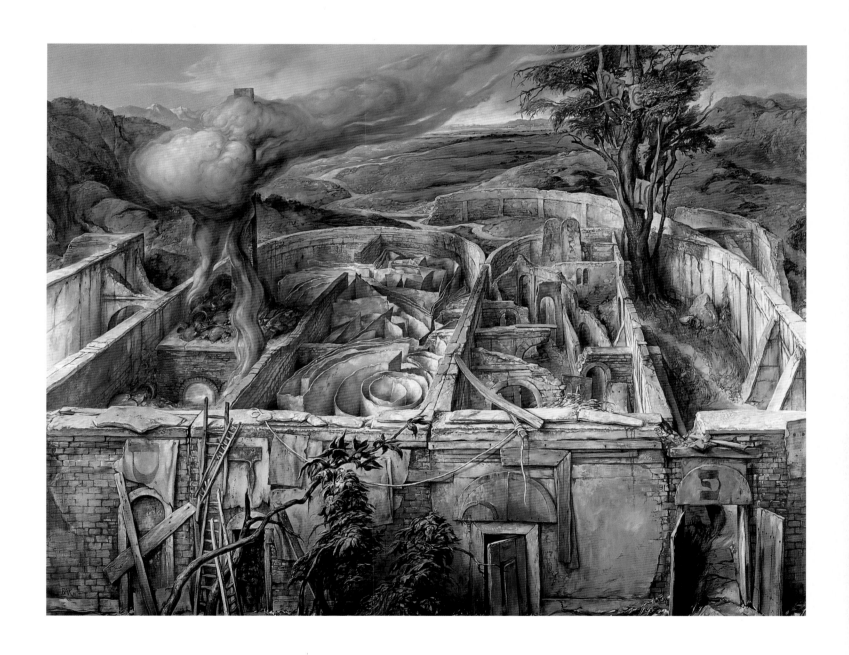

18. Transport

The title of this painting brings us back to the major veiled motif of the series: the near disappearance of the Jewish people from Europe. Instead of showing human beings lined up for deportation, Bak mummifies their habitats and belongings, wrapped for delivery to death much as the murderers shipped their former owners to a similar destination. This wretched assemblage of packaged goods will soon vanish from the landscape, leaving behind a rugged uninhabited terrain that challenges the imagination of the viewer to conjure up the wasted sites of ghettos in cities like Kovno, Vilna, and Warsaw after the Germans had burned them to the ground.

One of the many atrocious consequences of the Holocaust, in addition to the slaughter of millions of men, women, and children, was the ravaging of their roots, of the social and cultural traditions that they had passed from generation to generation. Here we see the very structures of a community under siege, moved from their literal and figurative foundations to a ruin from which there may be no recovery. The myth of resettlement, the illusion initiating transports such as these, is captured by the artist in this procession of possessions, raising the question of how the values and institutions they embody will retain their worth and identity after they have been wrested from their native locale.

Transport
1995-1996
160 x 200 cm
Oil on canvas

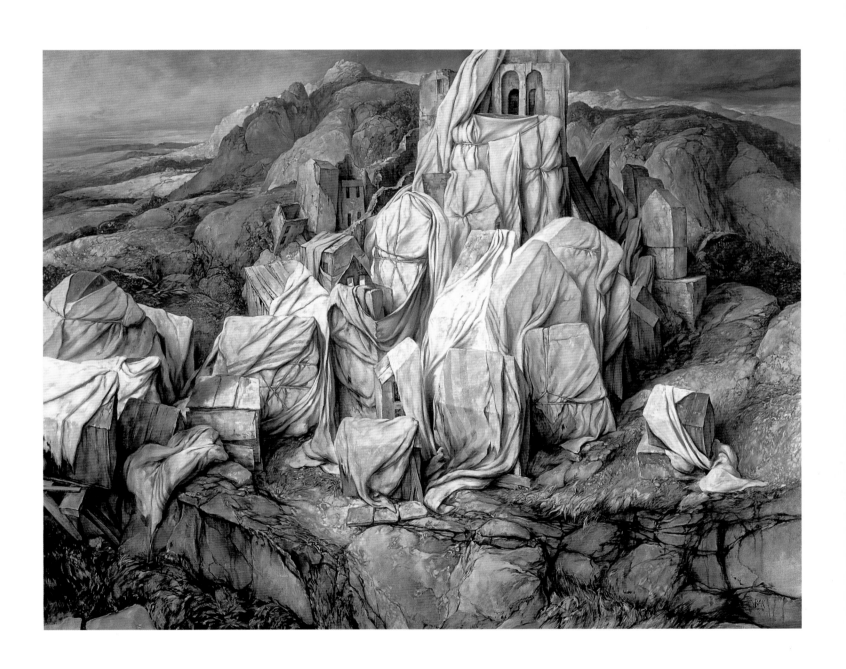

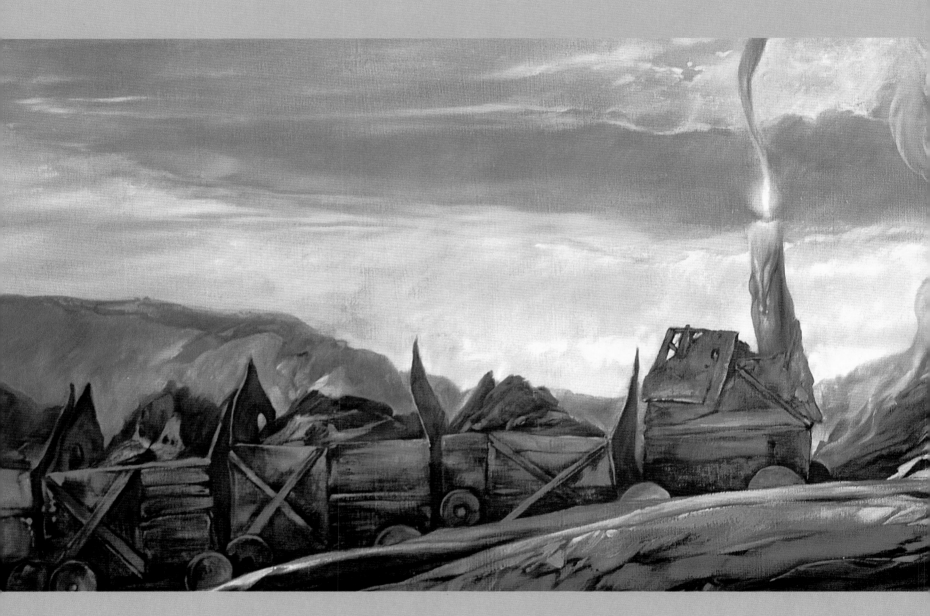

19. *Trains*

Like many other pairs of paintings in the *Landscapes of Jewish Experience*, *Transport* and *Trains* seem to be companion pieces. Lest we have any doubts about the fate of the deported community in *Transport*, the ruined buildings loaded on the open boxcars in *Trains* confirm its doom. The railway wagons converge on a smoking pyre in the center of the picture, ignited candles rising from the engines at their head in a kind of mournful memorial splendor.

Barely discernible in the foreground, the familiar letters of "Shema" ["Hear"] are dwarfed by the ominous dark cloud hovering over the landscape, though a bright distant sky, combined with the blazing candle flames, create a slight chiaroscuro effect by casting a lurid glow over the scene. But the sinister plumes of smoke that dominate the canvas with their vertical thrust cancel any possibility of the mysterious beauty that

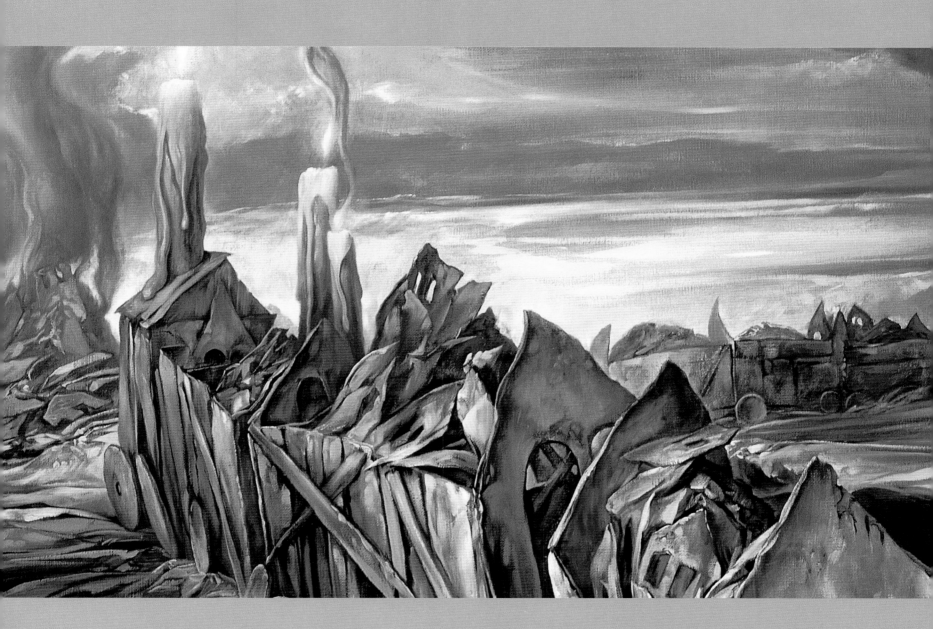

Rembrandt could achieve with this technique. The doomed cargo on its journey toward annihilation reduces the resonance of the Shema prayer to a feeble appeal. Neither nature nor supernature offers much consolation for the funereal vision of *Trains*, as the human cry of "Hear" seems to be met only with divine silence. Yet that "cry" is not lost in a void: it reaches the eyes and the ears of the viewer, who is obliged to respond to the tensions in this urgent visual text with the labor of interpretation.

Trains
1991
125 x 165 cm
Oil on canvas

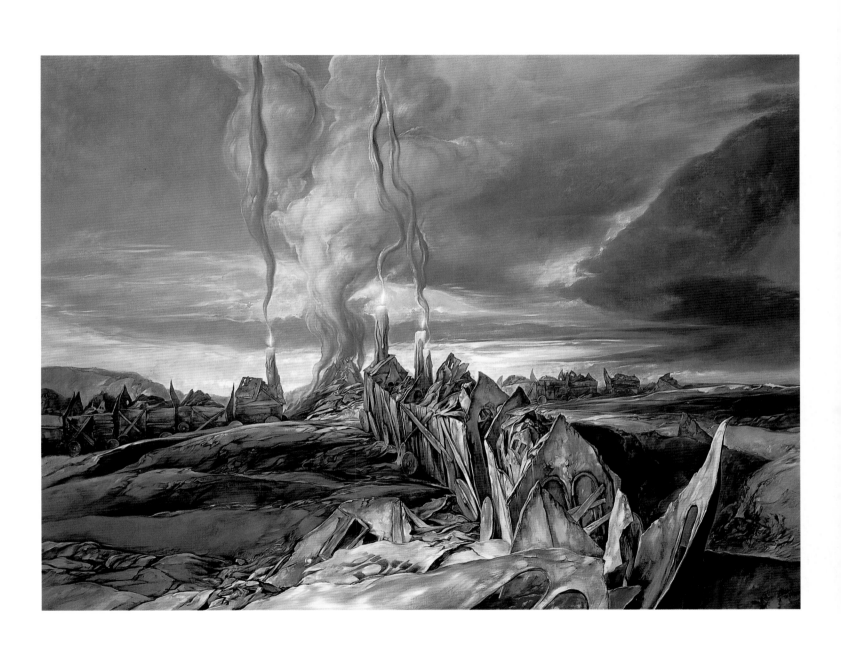

What has survived the catastrophe of the Holocaust? As the last painting in the series, *The Sounds of Silence* sums up many of the visual ideas that populate its predecessors. But it also leads us back in particular to the initial picture (several of whose images recur here), the *Self-Portrait* of the artist as a young boy who years later would draw on his vision of Jewish lives and his memory of Jewish deaths to create the entire cycle.

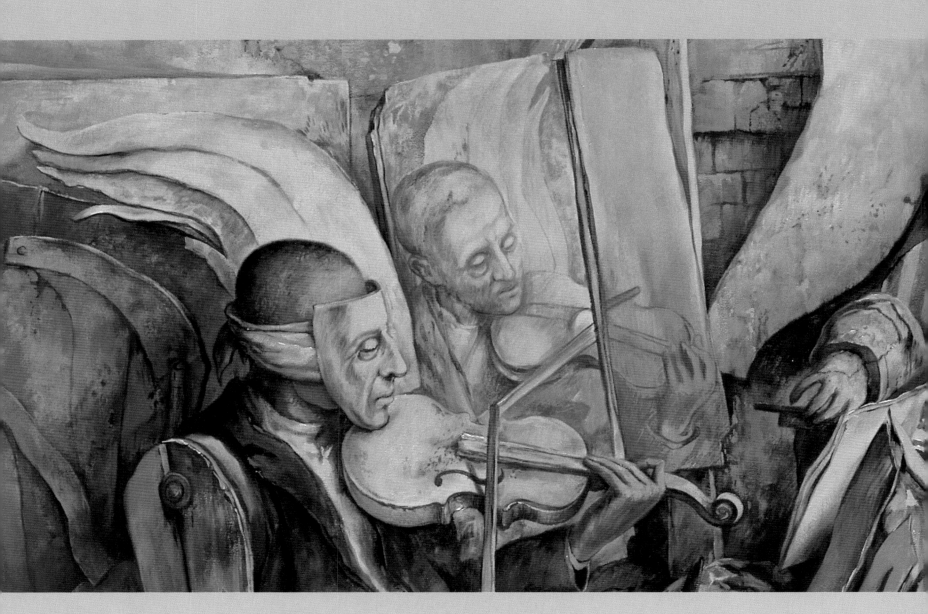

In the end is his beginning, as in the beginning was his end. His songs of innocence evolved into his songs of experience—the *Landscapes of Jewish Experience* that end and begin again in *The Sounds of Silence*.

By now, the viewer has little need to see the upper reaches of the brick facade and the smokestack; earlier canvases have trained the imagination to read beyond the frame of the painting. The wooden X presiding over the scene, a twisted cross, a Roman numeral ten, marks the spot where multi-

ple meanings collide: the 10 Commandments inscribed in stone by the hand of God lose some of their symbolic authority when they must share their image-world with the wall of this sinister chimney, an inanimate functionary of death in the universe of mass murder. Such visible paradoxes prevent us from celebrating *The Sounds of Silence* as a simple tribute to the triumph of art over attempted annihilation.

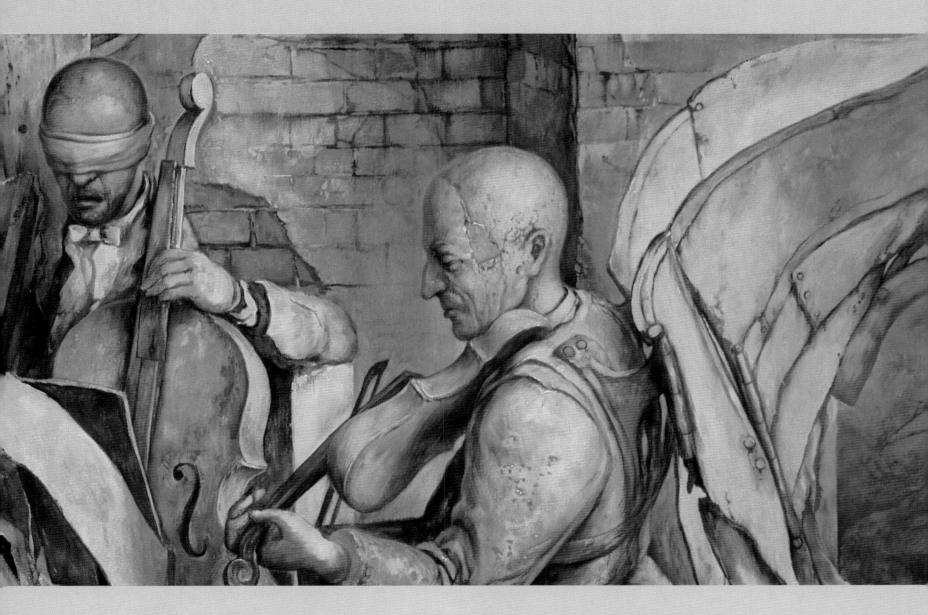

At least two silences haunt the atmosphere: the unheard strains of the music, whether lyrical or shrill, and the menacing hush of dissolution, from whose shadows the dismembered figures of the musicians have barely escaped. Like the child-victim of the Warsaw ghetto in *Self-Portrait*, they are fragmented selves, encumbered rather than freed by their wooden wings, a hint that their music may not soar lightly toward the heavens—

leaving uncertain the outcome of the ongoing contest between the powers of darkness and the vitality of the creative spirit.

The four musicians are only partly animate versions of their former personalities. Careful inspection reveals that they are sketched and sculpted from materials like wood, stone, and silhouettes, as much as from solid human flesh. A masked violinist, a blindfolded cellist still garbed in prison stripes and stroking an eerie blue cello, a violist sitting in or beside a cube with a single dot, as if some grim fate had shaped his future by a chance cast of the dice—in their haggard appearance they reflect the cry of the survivors in Nelly Sachs's poem "Chorus of the Rescued":

> We, the rescued,
> From whose hollow bones death had begun
> to whittle his flutes,
> And on whose sinews he had already
> stroked his bow—
> Our bodies continue to lament
> With their mutilated music.

At the musicians' feet lie the parchment ruins of Bak's cherished Vilna ghetto, together with the remnants of a Torah scroll from which those segments seem to have been torn. It is, in the language of the first of T.S. Eliot's aptly-named *Four Quartets*, "a place of disaffection." But it is also a place of, and for, poetry and music, both of which Bak has managed to absorb into his complex artistic vision. With an intuitive precision, he has embodied in *The Sounds of Silence* other lines by Eliot in the same quartet:

> Words move, music moves
> Only in time; but that which is only living
> Can only die. Words, after speech, reach
> Into the silence. Only by the form,
> the pattern,
> Can words or music reach
> The stillness...

This is one of the unique achievements of *The Sounds of Silence*: in it, Bak creates forms and patterns to help us face the chaos of the Holocaust (with its journey from living to dying) and enter its villainous stillness, by absorbing that chaos into the substance of his art. At the same time, here and elsewhere in the series, he re-creates the forms and patterns that Jewish memory mounts against extinction, thus maintaining the charged tension between hope and despair that distinguishes the *Landscapes of Jewish Experience* as a whole.

116

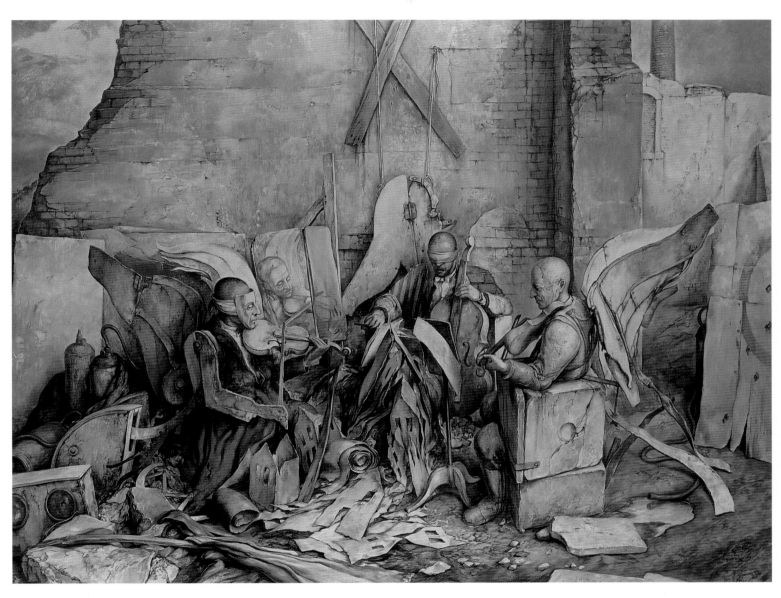

The Sounds of Silence
1995 160 x 200 cm Oil on canvas

Samuel Bak

Samuel Bak was born on August 12, 1933 in Vilna (Vilnius), at a crucial moment in modern history, in which fateful events lay ahead for this century. Bak's talent was first recognized during an exhibition of his works in the Ghetto of Vilna when he was nine. After the end of the World War II, he was placed in the Landsberg Displaced Persons Camp. At this time, he was enrolled in painting lessons at the Blocherer School, Munich. In 1948, he immigrated to the newly established state of Israel. After completing both his studies at Bezalel Art School in Jerusalem and his army service, he went to Paris in 1956. There he continued his studies at l'Ecole des Beaux Arts. He received a grant from the America-Israel Cultural Foundation to pursue his studies.

In 1959, he moved to Rome where his first exhibition of abstract paintings met with considerable success. In 1961, he was invited to exhibit at the "Carnegie International" in Pittsburgh. In 1963 two one-man exhibitions were held at the Jerusalem and Tel Aviv Museums. It was subsequent to these exhibitions, during the years 1963-1964, that a major change in his art occurred. There was a distinct shift from abstract forms to a metaphysical figurative means of expression. Ultimately, this transformation crystallized into his present pictorial language.

In 1966, he re-settled in Israel. He lived in New York City (1974-1977), in Paris (1980-1984) and in the Canton of Vaud, Switzerland (1984-1993). Since 1993 Samuel Bak has lived outside of Boston, in Weston, Massachusetts.

From 1959-1991 Samuel Bak had over 60 solo exhibitions at private galleries in New York, Boston, London, Paris, Berlin, Munich, Tel Aviv, Jerusalem, Rome, and other cities around the world.

Since 1979, large retrospective exhibitions have been held in the Museums of Heidelberg, Nuremberg, Bonn, Dusseldorf, Esslingen, Wiesbaden, Landau, Braunschweig, and Bamberg. A special exhibit entitled "Bak and Dürer" was shown at the Historic Dürer House in Nuremberg in 1989. In 1993 an exhibition of studies for the Landscapes of Jewish Experience theme and a part of the completed paintings was shown at the Jewish Museum in Frankfurt.

In the United States and Canada, exhibitions of Samuel Bak's work have been presented, since 1969, at the Brockton Art Center, Massachusetts (1969); Saidy E. Bronfman Center, Montreal (1970); Rose Art Museum, Brandeis University (1976); Koffler Art Gallery, Toronto (1989). In 1975, his work was included in an important exhibition: The Jewish Experience in the Art of the 20th Century at the Jewish Museum, New York. In 1990, his work was included in a related exhibition at the Barbican Center, London.

Since Bak's arrival in the United States, one man exhibitions of his work have been shown at the Charach/Epstein Museum, Detroit, the Spertus Museum in Chicago, the Wilshire Boulevard Temple/Gallery in Los Angeles and the Mizel Museum, Denver. Since 1994, a selection of Bak's works has been part of the group show entitled Witness and Legacy that has been travelling to North American museums and is scheduled to continue until the year 2000.

His works are included in major museums in the United States and abroad including: DeCordova Museum, Lincoln, Massachusetts. Dürer House, Nuremberg. Germanisches National Museum, Nuremberg. German Parliament, Bonn. Hood Museum, Dartmouth College, Hanover, New Hampshire. Israel Museum, Jerusalem. Jewish Museum, New York. Kunstmuseum, Bamberg. Municipality of Nuremberg. Rose Museum, Brandeis University, Waltham, Massachusetts. University of Haifa, Israel. Tel Aviv Museum of Art, Israel. Yad Vashem Museum, Jerusalem. Vaud State, Switzerland.

Monographs/Books *

* LETTERS TO JEAN
Samuel Bak
Aberbach Fine Art, New York, 1974

* BAK, PAINTINGS OF THE LAST DECADE
Paul T. Nagano, A. Kaufman
Aberbach Fine Art, New York, 1974

* BAK, DENKMALER UNSERER TRÄUME
Rolf Kallenbach
Limes Verlag, MÅnchen, 1977

* DIE ZERBRECHLICHE WELT DES SAMUEL BAK
Ernest Landau
Germanisches Nationalmuseum, Nuremberg, 1977

* DIE UNABWEISBARE MODERNITÄT VON SAMUEL BAK
WERKEN
Klaus Hennig
Kunstverein Braunschweig, 1978

* SAMUEL BAK, GEMÄLDE 1965-1987
Lothar Honnef
Stadtgalerie Bamberg, 1988

* SAMUEL BAK : THE PAST CONTINUES
Paul T. Nagano and Samuel Bak, Introduction by B. H. Pucker
Godine and Pucker Safrai Gallery, Boston, 1988

LES POIRES BIBLIQUES DE SAMUEL BAK
Alain Bosquet
Carpentier, Paris, 1988

SAMUEL BAK : STILL LIFE AND BEYOND
Pamela Wolfson
Pucker Safrai Gallery, Boston, 1989

BAK UND DÜRER
Matthias Mende
Dürer-Haus, Nuremberg, 1990

* CHESS AS METAPHOR : THE ART OF SAMUEL BAK
Jean Louis Cornuz
Pucker Safrai Gallery, Boston and C. A. Olsommer,
Switzerland, 1991

CHESS AS METAPHOR IN THE ART OF SAMUEL BAK
B. H. Pucker
Soufer Gallery, New York, 1992

LANDSCHAFTEN JÜDISCHER ERFAHRUNG
Text by Linda Reisch, Georg Heuberger, Amos Oz, Eva Atlan, and Samuel Bak
Jüdisches Museum Frankfurt am Main, Frankfurt, 1993

LANDSCAPES OF JEWISH EXPERIENCE
B. H. Pucker
Pucker Gallery, Boston, 1993

SAMUEL BAK : A RETROSPECTIVE JOURNEY
Sylvia Nelson and B. H. Pucker
Pucker Gallery, Boston, 1994

SAMUEL BAK : THE FRUIT OF KNOWLEDGE
Pamela M. Fletcher
Pucker Gallery, Boston, 1995

BAK : MYTH, MIDRASH AND MYSTICISM
Michael Fishbane
Pucker Gallery, Boston, 1995

SAMUEL BAK : LANDSCAPES OF JEWISH EXPERIENCE II
Essay by Pamela M. Fletcher, Commentary by B. H. Pucker
Pucker Gallery, Boston, 1996

Lawrence L. Langer

Lawrence L. Langer was born in New York City and educated at CCNY and Harvard. He is Alumnae Chair Professor of English emeritus at Simmons College in Boston. Author of numerous chapters and articles on Holocaust themes, he has also written several books, including *The Holocaust and the Literary Imagination* (1975), *The Age of Atrocity: Death in Modern Literature* (1978), *Versions of Survival: The Holocaust and the Human Spirit* (1982), *Holocaust Testimonies: The Ruins of Memory* (1991), which won the National Book Critics Circle Award for Criticism and was named one of the ten best books of the year by the editors of the New York Times Book Review, *Art from the Ashes: A Holocaust Anthology* (1995) and *Admitting the Holocaust: Collected Essays* (1995). In the fall of 1996 he was the J.B. and Morris C. Shapiro Senior Scholar-in-Residence at the Research Institute of the US Holocaust Memorial Museum, and in the spring of 1997 the Koerner Fellow for the study of the Holocaust at the Centre for Hebrew and Jewish Studies at Oxford University.

Afterword

*Man's quest for a meaning of existence is
essentially a quest for the lasting...The way to
the lasting does not lie on the other side of life; it
does not begin where time breaks off. The lasting
begins not beyond but within time, within the
moment, within the concrete...*

A.J. Heschel

Each of us seeks to discover the meaning of our existence and to
fashion a way of life that enriches the spirit and experience of
others. The Gallery has been our chosen instrument to share
our commitment to the quality of human life in our small uni-
verse. The art of others as selected by us has been the vehicle.

Central to the art and the artist have been Samuel Bak and his
work. For nearly three decades we have been privileged to
work with the man and share the extraordinary range of his cre-
ations. Nearly five years ago we were discussing the very large
canvases done by Marc Chagall in his eighties. These are beau-
tiful works but strain the physical limits of the artist.

Bak expressed the wish to do a concentrated body of large
works that would explore the *Landscapes of Jewish Experience*
theme... images filled with the Tablets, the Magen David,
Candles, the Tree of Life, Hebrew letters which had been pre-
sent in his artistic vocabulary since the early 1970's. He had
painted the themes with numerous variations. The images
slowly became a personal and public iconography as part of the
modern Jewish Experience.

The time seemed right to explore and expand these themes on
a large scale. At 58, Bak felt his energies to be ready. What was
needed was the means to set aside nearly 4 years to the creation
of such a major body of work.

We proposed the project to art patron and friend Matthew
Bronfman. We believed that Bak's life experience; the chance of

124

Afterword

his survival; the desire to paint these works as an act of Witness - all represented a meaningful and unique opportunity to create a lasting memorial.

Matthew's commitment to the artist and his art energized a group of patrons who underwrote the creation of these 20 paintings. For four years Bak worked thoughtfully and consistently to fashion these works so that each would stand alone and yet when experienced together - in exhibition or in book form - they would capture the modern experience as defined by the Holocaust.

As the works were born and the group of 20 was nearing completion, we realized that it was critical to keep the works together - to codify these *Landscapes of Jewish Experience*.

Each painting can and should be experienced on many levels. In order to open up these layers of meaning we turned to Professor Lawrence Langer - recognized scholar in Holocaust literature and winner of a National Book Critics Circle Award. He has responded with an illuminating essay and lucid responses to each painting. Through his eyes and knowledge we feel that each work and indeed the entire ensemble has become more available and engaging.

We are grateful to the artist Samuel Bak; the author Lawrence Langer; the patron Matthew Bronfman for sharing these works which we believe represent - at its best - our quest for the meaning of existence for our day and for those who will come after us.

Bernard H. Pucker